IMAGES
*of America*

# FOREST PARK

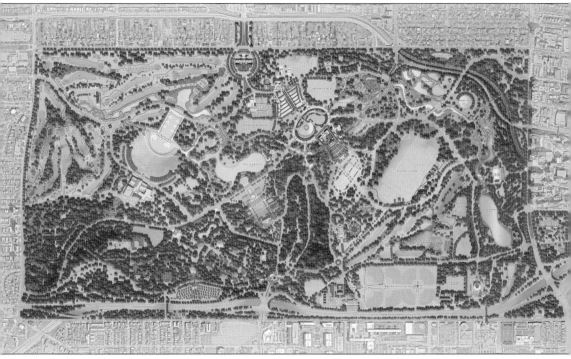

This is a Forest Park Forever modern map of Forest Park. Maps of Forest Park have seen many transformations since the sprawling park was officially opened to the public in 1876. The most recent maps reflect improvements made by the City of St. Louis and Forest Park Forever, including a sustainable system of lakes and lagoons with clearly defined borders. (Courtesy Forest Park Forever/H3 Studio, Inc.)

ON THE COVER: A festive gathering assembles at the Saint Louis Zoo, and many in the excited crowd begin the trek up to the zoo's first Elephant House. The old Elephant House was built in 1917 to provide a home for the beloved elephant, Miss Jim. To the left of the home for Miss Jim, the upper portion of the 1904 World's Fair flight cage for birds can be seen. (Courtesy Saint Louis Zoo Archives.)

# IMAGES
## *of America*

# FOREST PARK

Don Corrigan and Holly Shanks

ARCADIA
PUBLISHING

Published by Arcadia Publishing
Charleston, South Carolina

Printed in the United States of America

Library of Congress Control Number: 2017933261

For all general information, please contact Arcadia Publishing:
Telephone 843-853-2070
Fax 843-853-0044
E-mail sales@arcadiapublishing.com
For customer service and orders:
Toll-Free 1-888-313-2665

Visit us on the Internet at www.arcadiapublishing.com

*The authors dedicate this book to the more than 13 million people who make Forest Park come alive with their visits each year. They come, they discover, they enjoy, they support Forest Park.*

# CONTENTS

Acknowledgments                                                          6

Introduction                                                            7

1.   World-Class Park: World-Class Fair                                 9

2.   Missouri History Museum: Looking Back,
     Looking Forward                                                   21

3.   Saint Louis Zoo: World-Class Legacy                               29

4.   Saint Louis Art Museum: Art for St. Louis's Sake                  45

5.   Saint Louis Science Center and Planetarium:
     Constantly Evolving                                               55

6.   Meet Me at the Muny: Best of Outdoor Theater                      63

7.   Sports Mecca: Skating, Tennis, Golf, and More                     77

8.   Forest Park Happenings: Balloons and Tunes,
     Kites and Bites                                                   89

9.   Honoring the Nation, the Planet: Earth Day to
     Independence Day                                                 103

10.  Forest Park Forever: Keeping and Polishing a Gem                 113

Bibliography                                                          127

# ACKNOWLEDGMENTS

The institutions and organizations that helped make this book possible are too numerous to mention.

We would like to thank a few of the many people who helped in the process of this book: Sam Moore and Jaime Bourassa with the Missouri History Museum; Charles Hoessle and Christy Childs with the Saint Louis Zoo; Laura Peters with the St. Louis Municipal Opera; Mindy Peirce with the Saint Louis Science Center; Lesley Hoffarth, Stephen Schenkenberg, and Calla Massman with Forest Park Forever; Greg Hayes from the City of St. Louis Department of Parks, Recreation, and Forestry; Dan Zarlenga with the Missouri Department of Conservation; John Beck of KSHE-95; Roze Wolownik with Shakespeare Festival St. Louis; Maggie Hallam with the LouFest Music Festival; Anne Cox, Laura Jolley, and Nancy McIlvaney with the State Historical Society of Missouri; Rachel Aubuchon with the Saint Louis Art Museum; Jen Myerscough and Jean Ponzi with St. Louis Earth Day; Steve Pozaric and Julie Donnelly of Fair Saint Louis; Andrew Colligan with the Missouri Botanical Garden; and Lauren Ross with Bixby's.

Every effort has been made to acknowledge the correct copyright for images. Any errors or omissions are unintentional and should be notified to the authors for corrections to appear in any reprints.

# INTRODUCTION

Citizens of the St. Louis region take great pride in their gleaming Gateway Arch, their professional sports teams, and their world-class urban park, Forest Park. Residents like to point out that Forest Park is larger than New York City's famous Central Park. Forest Park is approximately over 500 acres larger than Central Park and packed with plenty of uplifting attractions.

Of course, St. Louis needed a very large park back in the 1800s. Planners agreed on that when the various interests came together after the Civil War to discuss the proposed park. Businessmen wanted a notable park that would attract visitors and hike nearby real estate values. Reformers, recreationists, and clergy wanted a park that could be a place of solace and refuge for workers, immigrants, and the poor. Politicians took note of the work a major park might provide for the unemployed party faithful.

St. Louis also needed a very large park because, as a top-tier city, it would need such a space when it came to hosting a world's fair. The 1904 event, otherwise known as the Louisiana Purchase Exposition, was designed to show off all the marvels of science, industry, culture, and the arts. There was a Palace of Electricity filled with dynamos, magnetic coils, and devices of the future. There was a wireless tower transmitting messages at 25 to 30 words per minute. There were performers and animals aplenty on the one-mile Ten Million Dollar Pike, also known simply as "the Pike," at the fair. There was a Palace of Education highlighting advances in learning from kindergarten to college. There was a Palace of Fine Arts for exhibiting archival images and treasures of the art world.

When the 1904 World's Fair concluded and the towers and palaces came down, St. Louis tried to restore the park to its former self, but that could never happen. The Louisiana Purchase Exposition of 1904, which brought visitors from around the globe, had a lasting impact on this grand city of the Midwest and its park. This became evident as prominent museums and renowned institutions began to find a permanent home on the expanse of Forest Park.

This book dedicates a chapter to each of the park's incredible institutions of art, science, and culture. The history of these institutions is the history of St. Louis and, indeed, the history of America. Consider the Missouri History Museum, which, in 1913, unveiled the first towering sculpture of the third US president, Thomas Jefferson, even as it began to document the settlement of the West. Consider how just 14 years later, that same museum would play a role in honoring an aviator named Charles A. Lindbergh, who conquered space and time with the first transatlantic flight. A replica of his airplane, *Spirit of St. Louis*, can be found at the museum to this day.

Two institutions that can trace their lineage directly to the 1904 World's Fair are the Saint Louis Art Museum and the Saint Louis Zoo. The Palace of Fine Arts from the 1904 exposition became the Saint Louis Art Museum, which today is fronted by a familiar symbol of St. Louis, the statue of France's King Louis IX from the 1904 World's Fair. The giant birdcage left in the park from the 1904 event was scheduled to be taken apart and moved to the National Zoo. St. Louis residents rallied to keep it in their town, and in a few short years, it became part of a new Saint Louis Zoo in Forest Park.

This book notes how the Saint Louis Art Museum has grown with a new century. It has expanded its collections and added new galleries as well as an outdoor sculpture garden. The Saint Louis Zoo, too, has come a long way since first acquiring the giant elliptical birdcage from the 1904 World's Fair. In 2016, the zoo was rated the best free attraction in the United States by the *USA Today* Readers' Choice Awards Program. It was selected as the winner over Central Park in New York City, Millennium Park in Chicago, and the Golden Gate Bridge in San Francisco.

The St. Louis Municipal Opera, or "Muny," at Forest Park is another St. Louis institution singled out for coverage in this book. In 2019, the "granddaddy of summer stock theatres" can celebrate a century of dancing, singing, operas, and musicals. The Muny has made memories for many St. Louis families with bright stars who have graced its stage over the years, including Bob Hope, Cab Calloway, Yul Brynner, Gene Kelly, Debbie Reynolds, Richard Harris, Mitzi Gaynor, Phyllis Diller, Red Skelton, Cary Grant, John Travolta, and more.

Stars of a different kind can be found just south of the Muny at the McDonnell Planetarium in Forest Park. Dedicated in 1962, the planetarium has dazzled people with its saucerlike exterior and astonished people with what goes on in its interior, from star and meteor displays to laser shows. By 2001, the planetarium had grown and linked to a multibuilding science center with displays, exhibitions, a five-story theater, and more. All of this propelled the Saint Louis Science Center to be rated as one of the top five such facilities in the country.

Beyond telling the story of the great museums and institutions situated in Forest Park, this book also notes the park's outdoor setting as a most convenient venue for cultural edification and joyous entertainment. Forest Park has been the site of stunning open-air performances of Shakespeare, the ear-pleasing contemporary music of LouFest, and the eye-popping spectacle of hot-air balloon races. Additionally, the park has hosted big events such as the Independence Day extravaganza of Fair Saint Louis and, in April, the St. Louis Earth Day Festival, which draws more people every year.

In recent years, the park has been utilized by educators to teach about ecology and the environment. Its acres of green space, habitats, and gardens provide the perfect outdoor lab for young people to appreciate the diverse and complex bounty of nature. Forest Park also serves as an outlet for recreation, including fishing, hiking, bicycling, golfing, boating, ice-skating, sledding, and more. Forest Park: It just happens to be one of the most exciting places to visit in 21st-century America.

# One

# WORLD-CLASS PARK
## WORLD-CLASS FAIR

Thirteen million people cannot be wrong. That is how many people flock to Forest Park each year to visit the region's world-class cultural institutions: Saint Louis Zoo, Saint Louis Art Museum, Saint Louis Science Center, Missouri History Museum, and St. Louis Municipal Opera. More come for the park's natural surroundings and its many "happenings," or to enjoy such recreational pastimes such as baseball, golf, tennis, bicycling, boating, fishing, ice-skating, Rollerblading, and more.

The vision of a substantial, dedicated park space for St. Louis can be traced to the Civil War period when city dwellers demanded a respite from the stress of industrialization and urban living. After years of political wrangling, land for Forest Park was purchased on the western edge of the city, and it was officially dedicated for use by the citizenry of St. Louis on June 2, 1876. Forest Park's initial 1,370 acres made it larger than New York City's famous 840-acre Central Park.

The new park's land would be needed for a colossal undertaking that began in 1901. That is the year that Forest Park was chosen as the official site for the Louisiana Purchase Exposition, otherwise known as the 1904 World's Fair. The international exposition's impact on the fields of science, art, architecture, and history is often overlooked due to an emphasis on its effects on popular culture.

The 1904 World's Fair is credited with the discovery of the ice-cream cone and popularization of such new food items as the hamburger, hot dog, peanut butter, and iced tea. In addition, the world's fair inspired the music of Scott Joplin and Billy Murray, who performed and made recordings of "Meet Me In St. Louis," which became the basis for both a musical film and successful play.

The St. Louis World's Fair left behind far more than innovations in food and song. A huge birdcage exhibited at the 1904 World's Fair became a focal point for establishing the Saint Louis Zoo, and it is used to this day. Architect Cass Gilbert's Palace of Fine Arts, featuring a grand interior sculpture court at the 1904 World's Fair, became the home of the Saint Louis Art Museum. It was expanded in 2012–2013.

The Administration Building for the Louisiana Purchase Exposition, a defining landmark for the grand event, now fronts the eastern entry to the campus of Washington University.

The Jefferson Memorial Building to honor Pres. Thomas Jefferson and his Louisiana Purchase, constructed with proceeds from the fair, was completed in 1913 and became the Missouri History Museum. It was expanded in 2002–2003.

Forest Park has been called "the heart of St. Louis" and it can be argued that the 1904 World's Fair is when that heart began to come to life in a big way. The ambitious exposition of 1904 brought more than 20 million visitors from around the world to St. Louis and Forest Park. The fair brought monuments, historic architecture, waterways, and landscapes to Forest Park—and an entire river that had become a nuisance was buried under the park.

By the late 20th century, some of the park's finest features dating back to the fair were showing their age. Tens of millions of dollars have been raised to refurbish Forest Park in a new century. The results are obvious and impressive, and it is not just about renovating physical structures. The first phase, entitled the "River Returns Project," took its inspiration from the historic River Des Peres buried under the park 100 years earlier. The intention now is to enhance the park's water features and green spaces to create a sustainable ecosystem to benefit both humans and wildlife.

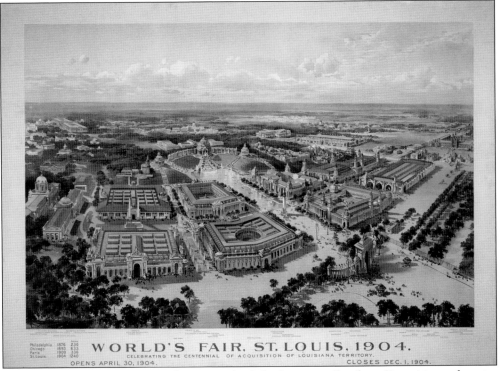

An aerial view depicts the sprawling grounds of the Louisiana Purchase Exposition, otherwise known as the St. Louis World's Fair of 1904. Fountains, statues, lush landscaping, palaces to industry, and innovation—all filled the western reaches of an impressive urban park: Forest Park. (Courtesy Missouri History Museum, St. Louis.)

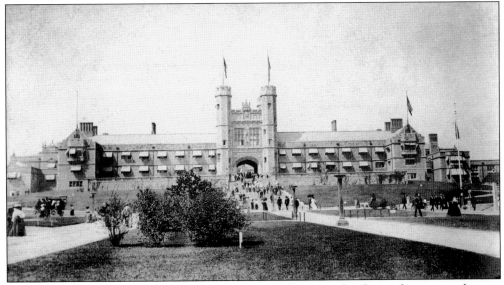

The turrets of Washington University's Brookings Hall were as familiar to fairgoers as they are now to the prestigious university's students. That is because the monumental building that fronts the eastern edge of the university campus was the Administration Building for the 1904 World's Fair. (Courtesy State Historical Society of Missouri, Columbia.)

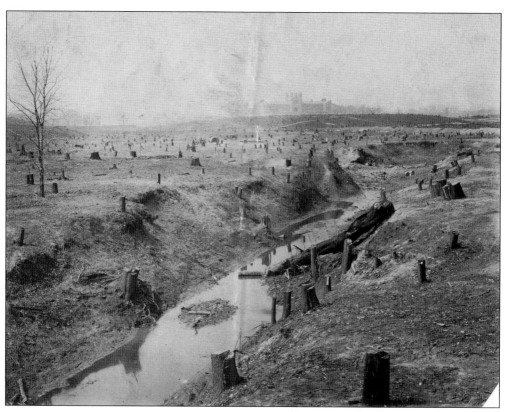

Preparation for the grounds of the 1904 World's Fair started with the virtual clear-cutting of the park's timber to make space for the Louisiana Purchase Exposition. As park advocates surveyed a field of tree stumps, they worried about the task of restoring Forest Park after the big event. (Courtesy Missouri History Museum, St. Louis.)

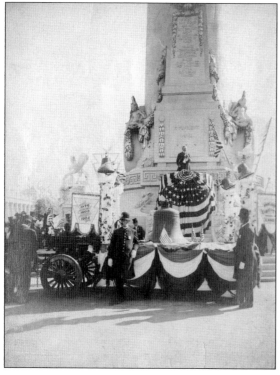

The 1904 World's Fair was not just about the marvels of science, culture, and the arts. The fair was a celebration of freedom for a relatively young nation. The Liberty Bell was loaned to the fair after a petition signed by 9,000 local schoolchildren requested that it travel to St. Louis. (Courtesy State Historical Society of Missouri, Columbia.)

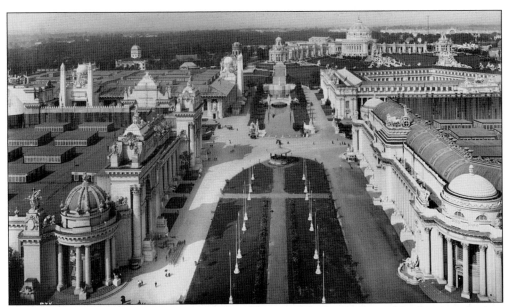

A view from a perch in the De Forest Wireless Tower reveals the expanse of the fairgrounds. As a promotion for a new form of communication, the wireless telegraph company had 10 installations and a transmission tower for the Louisiana Purchase Exposition. (Courtesy Missouri History Museum, St. Louis.)

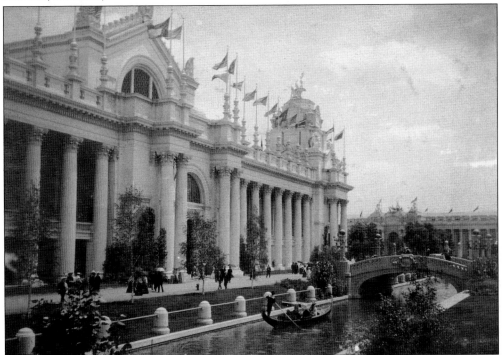

The Palace of Electricity was a major exhibition of new technology at the exposition in St. Louis. Fairgoers could view the remarkable advances in electrical engineering with motors, dynamos, and electrical machinery in action in the confines of a classical building. (Courtesy State Historical Society of Missouri, Columbia.)

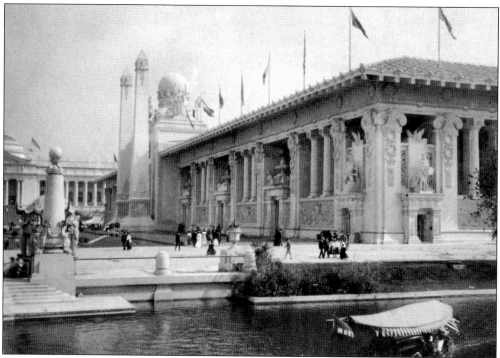

The Palace of Mines and Metallurgy offered visitors nine acres of displays of minerals of the world and the mechanical devices used to mine them. The architecture of the building itself was described as the unification of Egyptian, Greek, and Assyrian elements. (Courtesy State Historical Society of Missouri, Columbia.)

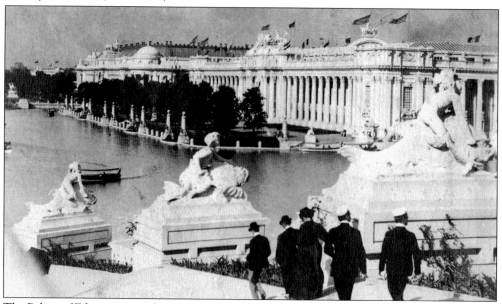

The Palace of Education stood on the east side of Forest Park's Grand Basin and could be accessed by several beautiful bridges. The exhibits covered kindergarten to the latest coursework required for a university education, as well as the training for the deaf and the blind. (Courtesy State Historical Society of Missouri, Columbia.)

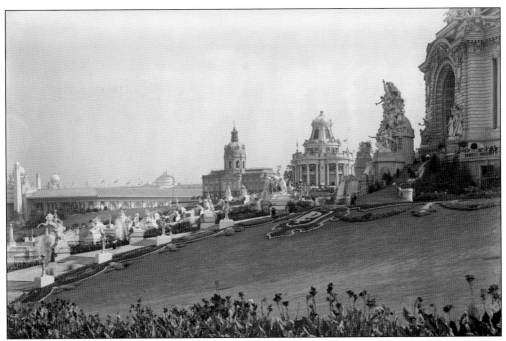

A view looking southeast toward Festival Hall was available from the west wing of the Cascades. At night, both wings of the Cascades were illuminated by fireworks displays over the 1904 World's Fair. The Cascade Gardens were bathed in the rockets' red glare. (Courtesy Missouri Botanical Garden Archives.)

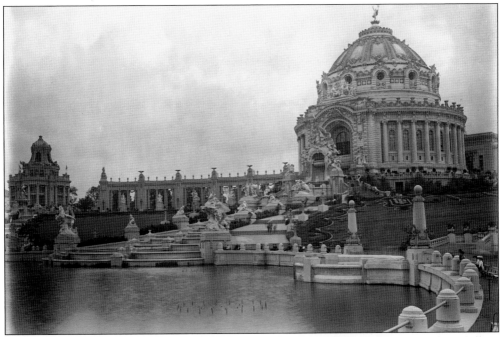

The dome of the World's Fair Festival Hall rose some 200 feet above the crown of the hill on which it was erected. A system of carpet bedding sloped gracefully down to the rippling waters of Forest Park's Grand Basin. (Courtesy Missouri Botanical Garden Archives.)

Although the loss of trees and water features alarmed some St. Louis residents when the city prepared to make way for the world's fair, they were later wowed by the splendid gardens near the French Palace of the Louisiana Purchase Exposition. (Courtesy Missouri Botanical Garden Archives.)

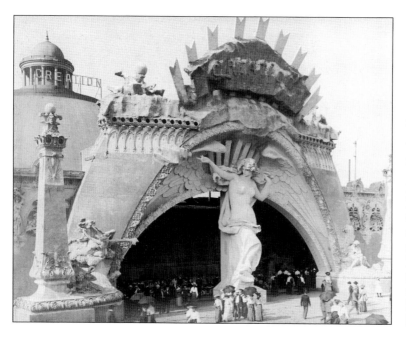

A towering statue beckons fairgoers to enjoy more marvels at the 1904 World's Fair. The stately lady is part of the entrance to Creation on the Ten Million Dollar Pike at the 1904 event. (Courtesy Missouri History Museum, St. Louis.)

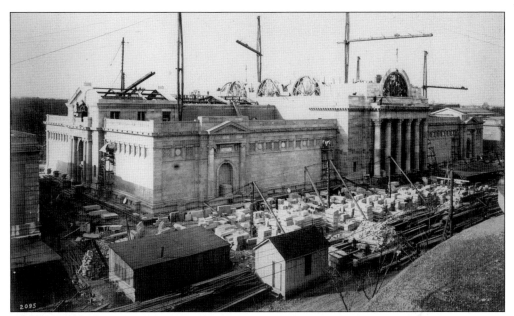

The 1904 World's Fair Palace of Fine Arts eventually became the home of the Saint Louis Art Museum. The grand structure designed by Cass Gilbert is the only permanent building in Forest Park remaining from the time of the great fair. (Courtesy Missouri History Museum, St. Louis.)

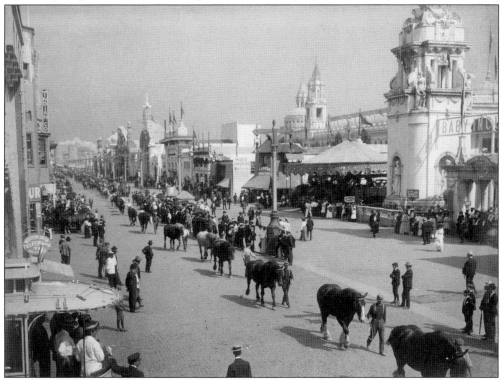

The Ten Million Dollar Pike at the world's fair was nearly a mile long and paved with bricks. The Pike's attractions included 6,000 performers and 1,500 animals. A lengthy parade of draft horses opened the fair's equine show in 1904. (Courtesy Missouri History Museum, St. Louis.)

Forest Park Lake was built during the decade before the 1904 World's Fair and was a work project for the unemployed in St. Louis. The lake itself, also known as Post-Dispatch Lake, was popular year-round, with boat rentals from a concession building in the summer and ice skate rentals in the winter. (Both, courtesy Missouri History Museum, St. Louis.)

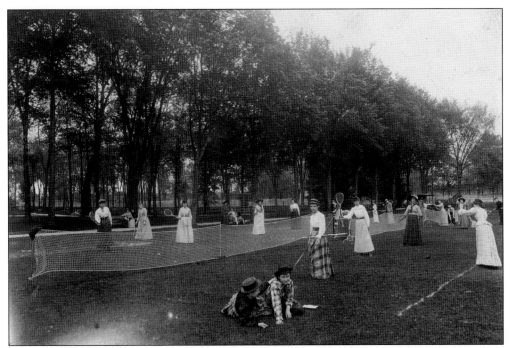

Many St. Louis residents were familiar with Forest Park even before the 1904 World's Fair. That familiarity was due to the park's recreational opportunities. Lawn tennis was especially popular; here, it is enjoyed by athletic women of an earlier era. (Courtesy Missouri History Museum, St. Louis.)

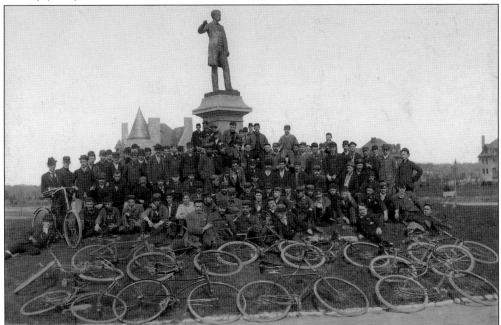

By the time of the world's fair, cyclists, pedestrians, and motorists were struggling to coexist on busy St. Louis thoroughfares. Forest Park became a favored site for cyclists. Bicyclists of the League of American Wheelmen have gathered by the park's Frank Blair statue before launching their cycling tours. (Courtesy Missouri History Museum, St. Louis.)

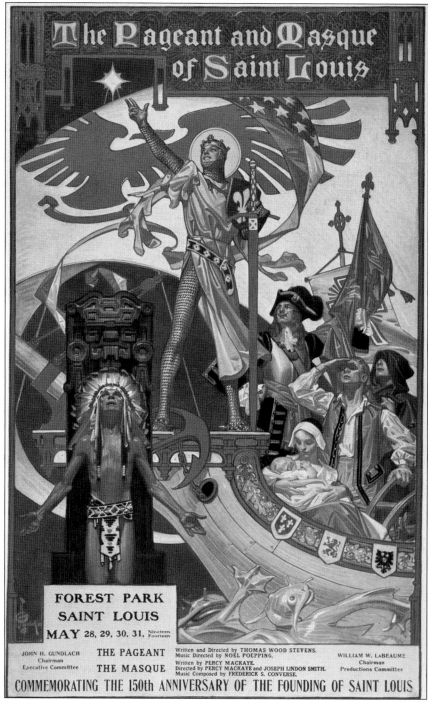

Ten years after the 1904 World's Fair celebrated the great expansion and exploration of the Louisiana Purchase, St. Louis residents readied to celebrate the 150-year anniversary of the founding of their city. They did this with theatrical performances of *The Pageant and Masque of St. Louis*. The 1914 performances in the park foreshadowed the establishment of the park's municipal opera. (Courtesy Missouri History Museum, St. Louis.)

*Two*

# MISSOURI HISTORY MUSEUM
## LOOKING BACK, LOOKING FORWARD

In 2016, the Missouri History Museum celebrated the 150-year existence of the Missouri Historical Society not only with a summer anniversary party but also with its usual run of great exhibits ranging from *Route 66, America's Mother Road* to the *1904 World's Fair: Looking Back at Looking Forward*. The museum sponsored workshops on genealogy and archaeology, as well as concerts, theater programs, and walking tours. The founders of the Missouri Historical Society, who met in the Old Courthouse in St. Louis to form the society, would have been proud of the museum's sesquicentennial celebration.

The 47 founding members of the Missouri Historical Society came together in 1866 with "the purpose of saving from oblivion the early history of the city and state." By the turn of the 20th century, the society had outgrown a deteriorating museum in downtown St. Louis and plans were made to locate in Forest Park. The success of those plans is evident today in the amazing Beaux-Arts structure that the Missouri Historical Society calls home.

The Missouri History Museum is yet another St. Louis institution that benefited from the 1904 World's Fair in Forest Park. Erected at the official entrance of Forest Park, the building memorialized Pres. Thomas Jefferson's pivotal role in the Louisiana Purchase.

A nine-foot statue of Jefferson rests just inside the entrance of the Missouri History Museum. Thousands of St. Louis residents greeted the marble statue of America's third president when it was unveiled in 1913, and many tens of thousands more have since paid deference to Jefferson. Another towering figure with a penchant for exploration was celebrated in 1927, when crowds turned out in Forest Park for famed aviator Charles A. Lindbergh. The man who flew his *Spirit of St. Louis* on a solo transatlantic flight would provide his medals, trophies, and air travel artifacts for display at the museum.

The Lindbergh collection has been a major feature of the museum through America's bicentennial in 1976 and is accented today by a replica of the *Spirit of St. Louis* aircraft displayed high above the museum's Grand Hall. When another bicentennial arrived in 2004—the 200-year anniversary of the Corps of Discovery Expedition—the Missouri History Museum put together an acclaimed

traveling exhibition that toured nationally, *Lewis & Clark: The National Bicentennial Exhibition.* Literally hundreds of artifacts were assembled for display from the expedition of Meriwether Lewis and William Clark that launched out of St. Louis in 1804.

When the museum itself celebrated its own sesquicentennial in 2016, the Missouri History Museum could boast more than 175,000 artifacts from the time of the Louisiana Purchase, the settling of the American West, the lofty feats of aviation's Charles Lindbergh and more recent explorations of land, air, and space. The collections and their admirers benefitted from the opening of the Emerson Center in 2000, an expansion featuring an auditorium, classrooms, exhibition space, and a noted ground-to-roof glass facade on the museum's southern exposure.

"In addition to our historic Beaux-Arts building and the exhibitions at the Missouri History Museum, we're also incredibly proud of our Library and Research Center on Skinker Boulevard," said Missouri History Museum president Frances Levine. "It's located in the restored former home of St. Louis's United Hebrew Congregation. This facility houses the treasures that serve as the basis for our exhibitions and public programs. It also offers researchers the chance to explore their community's history, regardless of whether professional scholars or informal researchers on topics ranging from genealogy to house history."

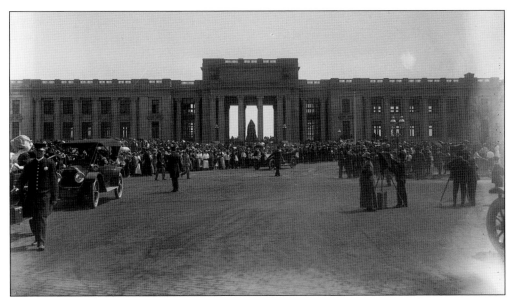

The Jefferson Memorial, also known as the Missouri History Museum, was designed by Isaac Taylor. St. Louis residents came for a dedication of the memorial building in 1913, and it stands at what was the main entrance to the 1904 St. Louis World's Fair. (Courtesy Missouri History Museum, St. Louis.)

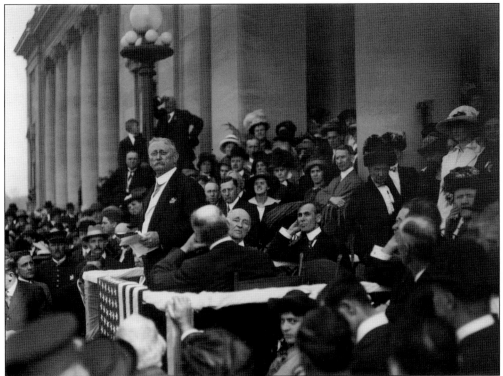

The presentation ceremony of the Jefferson Memorial Building brought together local and national dignitaries. Speeches noted the acquisition of vast lands west of the Mississippi River during the administration of Thomas Jefferson. (Courtesy Missouri History Museum, St. Louis.)

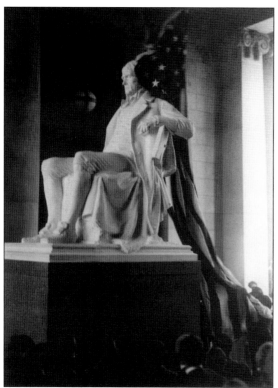

The unveiling of the statue of Thomas Jefferson, prominently displayed at the Missouri History Museum, is notable as the first national monument to Pres. Thomas Jefferson. The statue was created by sculptor Karl Bittner and is as impressive today as it was in 1913 at its dedication. (Courtesy Missouri History Museum, St. Louis.)

Art Hill at Forest Park was never as crowded as it was on June 19, 1927, when throngs of well-wishers greeted aviator Charles A. Lindbergh. The first man to fly an airplane across the Atlantic Ocean flew over Forest Park as part of a great celebration of an American triumph. (Courtesy Missouri History Museum, St. Louis.)

Aviator Lindbergh swooped over the crowd at Forest Park in his *Spirit of St. Louis* and received a rousing welcome. Today, a replica of the *Spirit of St. Louis* is suspended high in the Missouri History Museum's Grand Hall. (Courtesy Missouri History Museum, St. Louis.)

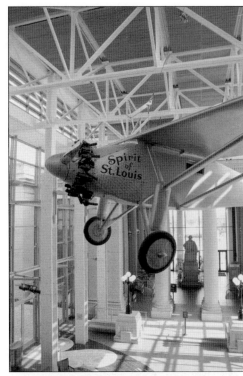

Visitors to the Missouri History Museum enjoy the exhibit of the Charles A. Lindbergh collection in 1932. The displays included many mementos from the aviator's flight to Paris, as well as medals and trophies given to Lindbergh from around the world. (Courtesy Missouri History Museum, St. Louis.)

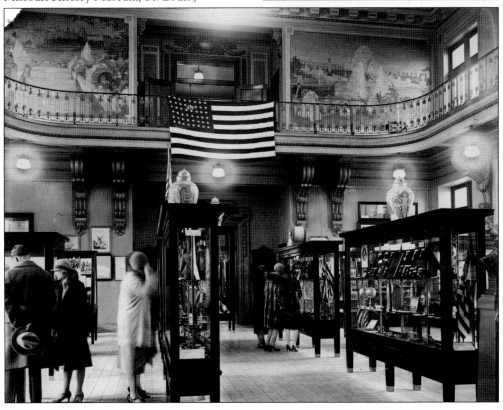

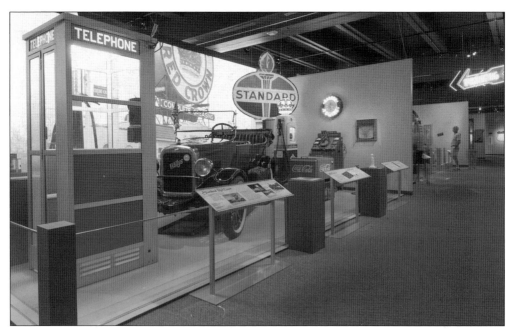

*Route 66: Main Street Through St. Louis* is one of the Missouri History Museum's more recent historical exhibits. Artifacts for the unique display ranged from vintage gasoline pumps to neon roadside advertising signs. "The Mother Road of Main Street America" changed the face of St. Louis. (Courtesy Missouri History Museum, St. Louis.)

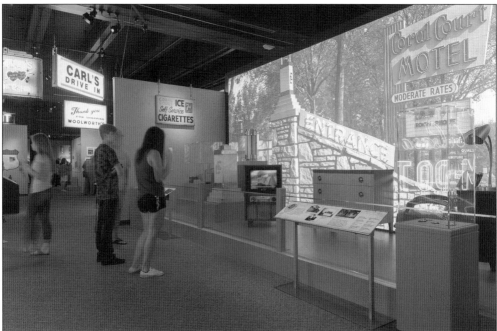

Missouri History Museum curators create exhibits, in part, by seeking out stories to tell in their ever-changing shows for their many visitors. The exhibit for Route 66 featured entertaining tales of tourist traps, unusual motels, hamburger joints, and custard stands along the famous highway. (Courtesy Missouri History Museum, St. Louis.)

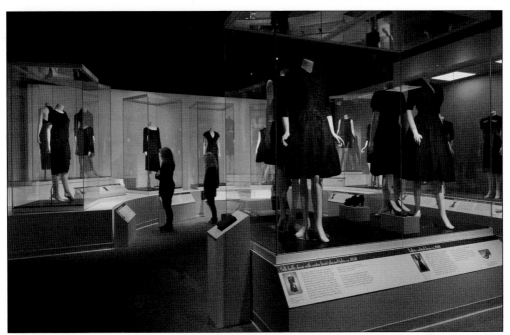

*Little Black Dress: From Mourning to Night* found a ready audience with its unique displays at the Missouri History Museum. The exhibit noted that the wearing of black has long been in decline at funerals and memorials and now is making an appearance at expensive weddings and elegant social occasions. (Courtesy Missouri History Museum, St. Louis.)

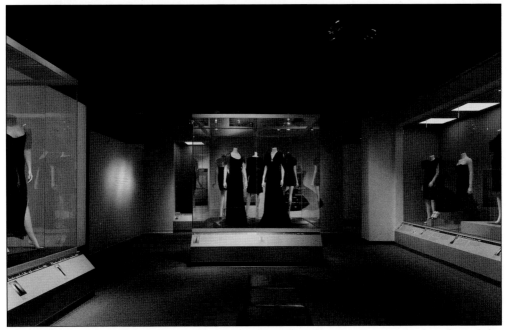

The Missouri History Museum's world-renowned textile collection was essential to the exhibit *Little Black Dress: From Mourning to Night*. More than 60 dresses from the collection illustrated the transition of black from a representation of profound grief to a symbol of high fashion. (Courtesy Missouri History Museum, St. Louis.)

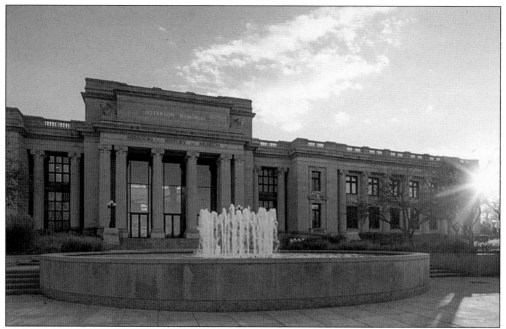

The north front of the Missouri History Museum remains true to its original Beaux-Arts architectural design. Six Tiffany pendant light fixtures accent the loggia of the historic building, with ornate Tiffany bronze doors greeting visitors to the museum. (Courtesy Missouri History Museum, St. Louis.)

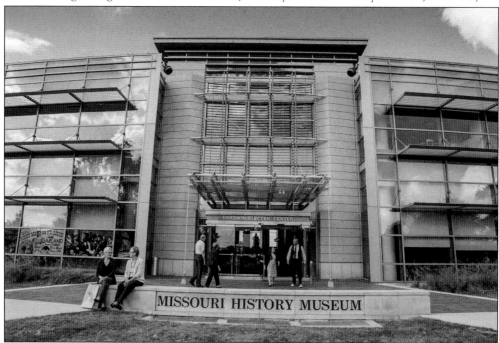

The Emerson Center of the Missouri History Museum, designed by Gyo Obata, is part of an ambitious program to take the museum into the 21st century. The heavy stone exterior of the building front is now balanced by the glass facade of an expansion containing galleries, classrooms, an auditorium, and more. (Courtesy Missouri History Museum, St. Louis.)

# Three

# SAINT LOUIS ZOO
## WORLD-CLASS LEGACY

At the entrance of the Saint Louis Zoo in Forest Park stands the 100-ton sculpture *Animals Always*. The largest sculpture at any public zoo in the United States, it features more than 60 animals happily enjoying sculpted ferns, trees, and plant life. The steel menagerie depicts fish, fowl, animals, and plant life—some that are listed as endangered species. Their representation is meant, in part, to inspire visitors to appreciate and protect the natural world.

*Animals Always* greets visitors on the south side of Forest Park. On the north side of the zoo grounds is the towering metal flight cage for birds. The Smithsonian Institution commissioned the flight cage for the Louisiana Purchase Exposition, better known in St. Louis as the 1904 St. Louis World's Fair. The amazing flight cage was to be taken apart and moved to the National Zoo in Washington, DC, after the fair's conclusion. But St. Louis residents would have none of that. They rallied to keep the flight cage intact, and the City of St. Louis soon purchased it for $3,500. Within a few short years, it served as the impetus for the Saint Louis Zoological Society to develop a full-fledged zoo—the first municipally supported zoo in the world.

The City of St. Louis set aside 77 acres in Forest Park for a zoo, and the Missouri General Assembly provided the financial arrangements for the Saint Louis Zoo to be declared "forever free." This declaration meant that all citizens could enjoy the zoo, not simply those who could afford a price of admission. After the acquisition of the giant elliptical flight cage for birds, the new Saint Louis Zoo began adding more exhibits and displays. Among the first major exhibits were the uniquely constructed bear pits, which opened in 1921. The bear pits began a tradition of trying to provide zoo enclosures for animals that might mirror their original habitats in the wild.

Some of the zoo's most memorable attractions were constructed during the 1920s and 1930s, including the Primate House, Reptile House, Antelope House, and more. A "herpetarium" was the province of a young man names Charles "Charlie" Hoessle, who brought his love of snakes and reptiles to the zoo in 1962. He would learn the magic of running a zoo from many inspirational mentors, including two legendary Saint Louis Zoo superintendents—George Vierheller and Marlin Perkins.

Vierheller was a master at putting animal shows together and bringing in visitors with chimpanzee tea parties and daring stunts with big cats such as lions and tigers. Perkins, who succeeded Vierheller, lassoed the power of a new medium, television, with *Mutual of Omaha's Wild Kingdom*. It became possible to educate a worldwide audience about animals. When Hoessle rose to become head of

the zoo in 1982, he also utilized television as host of the *Saint Louis Zoo Show*. Hoessle became the sixth director of the zoo and retired in 2002. He brought an approach that emphasized concern for animal health and wildlife management, beyond the display of animals for amusement.

"The original mission of the Saint Louis Zoo has never changed: to educate the public, to entertain the public, to encourage conservation and the protection of animal life," said Hoessle. "Our Zoo in Forest Park has become an extremely important scientific resource on animals and for worldwide conservation. The amusement is still there, and the Zoo is for people to have fun. They can learn as much or as little as they want. One thing is for sure, the people who work at the Zoo love animals, but they also love people. And they make it their business to learn as much as they can about the animals in order to care for them, but also to teach others about them."

In recent years, the Saint Louis Zoo has added such exhibits as a 9,000-square-foot "insectarium," a Penguin and Puffin Coast habitat, and the Polar Bear Point. A new polar bear resident, Kali, entertains crowds on two levels: above water and below water. Polar Bear Point also helps educate visitors about the effects of a warming Earth and climate change on wildlife in the natural habitats where they actually live. An additional Saint Louis Zoo innovation is the WildCare Institute. After Dr. Jeffrey Bonner became president and chief executive officer of the zoo in 2002, he asked the staff to brainstorm about how the Saint Louis Zoo could best use its resources and connections for conservation programs. Under his leadership, the WildCare Institute was crafted with 12 conservation centers supporting research and conservation activities for critically endangered species.

"Nearly 180 million visitors go to accredited zoos and aquariums around the world – the Saint Louis Zoo alone welcomes 3.2 million annual visitors who can be amazed by nearly 15,000 animals and 630 species," explained Dr. Bonner. "Coming to the Zoo is fun for the family, but our research shows it also awakens concern and awareness about the needs of other creatures. In the end, saving animals means saving ourselves because if we save wild things and wild places, we ensure that the diversity of life remains rich."

Visitors entering Forest Park from Hampton Avenue will encounter more than 60 animals peeking out from behind sculpted trees and ferns. They are all part of the *Animals Always* sculpture by Albert Paley, who came up with the idea of a steel menagerie weighing 100 tons and measuring 130 feet long by 36 feet high. *Animals Always* is the largest sculpture at any public zoo in the United States. The sculpture not only provides a solid welcome to the zoo but is also meant to inspire future generations to protect the natural world. (Courtesy Saint Louis Zoo/Roger Brandt.)

In November 1910, the Zoological Society of St. Louis was established without fanfare. The founders, originally with the St. Louis Naturalists Club, include, from left to right, ornithologist Otto Widman, Prof. J.F. Abbott of Washington University, shirt manufacturer Cortlandt Harris, herpetologist Julius Hurter, and taxidermist Frank Schwarz. All of them were immigrants from Europe, where zoos were reserved for royalty and the upper classes. The society founders wanted a zoo that would be "forever free" and accessible to all. (Courtesy Saint Louis Zoo Archives.)

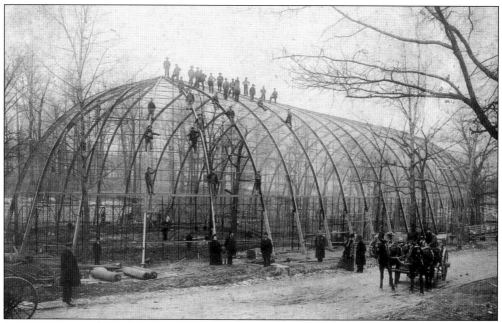

Construction workers take time out for a photograph while building a giant birdcage for the Smithsonian Institution for the 1904 World's Fair. The Saint Louis Zoo credits the photograph as a family heirloom belonging to Tracy Ronvik of St. Louis, whose great-grandfather Gustav Knudsen Ronvik is thought to be one of the workers atop the amazing structure. During the fair, as many as 1,000 birds flew within the 228-foot-long cage. (Courtesy Saint Louis Zoo Archives.)

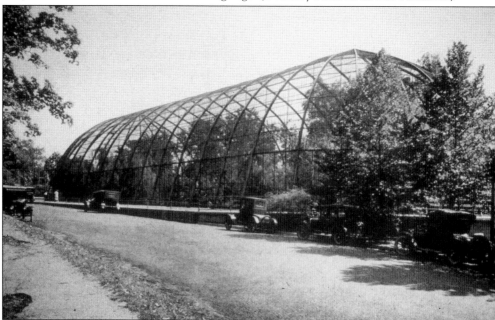

The largest free-flight cage for birds in the world at the time of the 1904 fair, it was supposed to be dismantled and shipped to Washington, DC, for the Smithsonian. St. Louis residents were not about to give up their birdcage and arranged to purchase it from the Smithsonian. There might not have been a Saint Louis Zoo were it not for the birdcage. (Courtesy Saint Louis Zoo Archives.)

Rock outcroppings in the Herculaneum area became the inspiration for a natural home for bears at the Saint Louis Zoo. Bear pit builders took on the task of casting plaster molds of the rock bluffs in Jefferson County, Missouri. The casts were then brought back to Forest Park and concrete was poured behind them to make a backdrop and enclosure closely resembling a setting that bears would find more comfortable than the original iron-bar cages. (Courtesy Saint Louis Zoo Archives.)

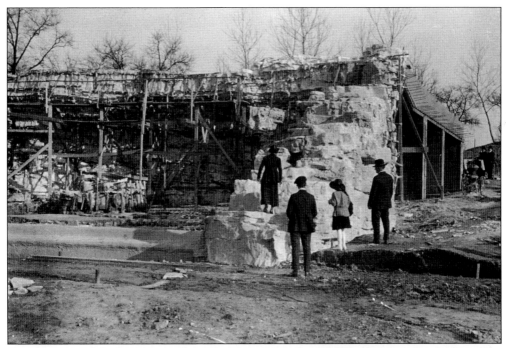

Construction of the bear pits with casts, concrete, and scaffolding fascinated onlookers. The opening of the bear exhibits in 1921 was hailed as major zoological innovation and brought visitors from around the world to inspect them. The Saint Louis Zoo established a series of five bear pits in which the animals could be out in fresh air and exhibited in natural surroundings. The new habitat was not only a boon for the bears but also a plus for visitors who could get a more three-dimensional view of the zoo's bears. (Courtesy Saint Louis Zoo Archives.)

Forest Park employees built a house for monkeys at the Saint Louis Zoo in 1905. A Primate House for monkeys and great apes was built with original Spanish-style architecture in 1925. The Primate House was renovated in 1977 and the Spanish-style architecture of the structure was preserved, but the animal enclosures were completely redesigned. Traditional barred cages gave way to updated large exhibits with colorful murals, rock formations, branches, ropes, and live plants. Apes and their relatives were then housed in social groups typical in the wild. Separated only by glass from active family groups, visitors can now watch a panorama of grooming, foraging for food, playing, and parenting. (Left, courtesy Saint Louis Zoo/ Ray Meibaum; below, courtesy Saint Louis Zoo/Michael Jacob.)

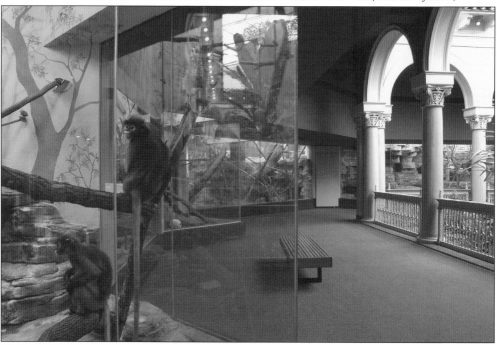

For 40 years as head of the Saint Louis Zoo, George Vierheller built one of the most important zoos in the world in Forest Park. He was photographed by the news media with his pals Miss Jim the elephant, Phil the gorilla, Harry the rhino, and the elephant seal known as Moby Dick. Vierheller said he wore many hats in his role as "Mr. Zoo," from public relations man to animal dietitian and first-aid expert, to talent scout and casting director. (Courtesy Saint Louis Zoo Archives.)

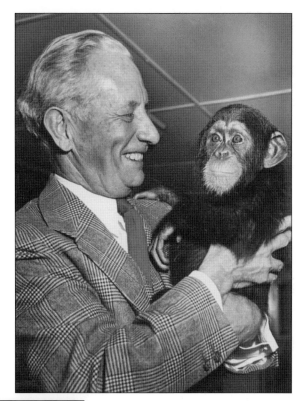

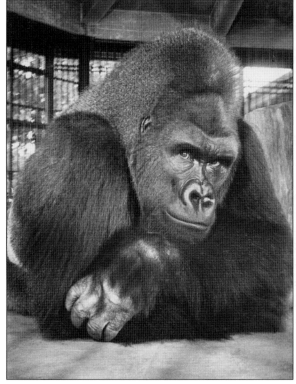

A 26-pound marvel known as Phil the gorilla arrived at the Saint Louis Zoo in Forest Park in 1941. He entertained zoo visitors by swinging from trees made of welded pipe, splashing in his pool, and throwing an old tire at his cage bars until his death in 1958. He was a star of the media, and in 1954, *Life* magazine ran a photo spread heralding the St. Louis celebrity as a "Rising Young Gorilla." (Courtesy Saint Louis Zoo Archives.)

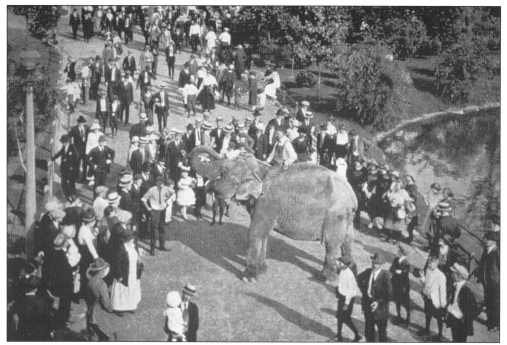

When the Saint Louis Zoo sought its first resident elephant in 1916, officials enlisted the help of area schoolchildren to make it happen. The children collected pennies and bought an Asian elephant that had once been a circus performer. As a nod of appreciation to the schools, plans were made to name the elephant for St. Louis School Board president James Harper. The elephant was a female, however, so she became simply Miss Jim. (Courtesy Saint Louis Zoo Archives.)

From the beginning of zoos, animals have always needed dedicated keepers. Duties included cage cleaning, animal feeding and general care services. Zookeepers have come a long way since the era of Phil the gorilla and Harry the rhino at the Saint Louis Zoo. Many are now animal specialists and educators of the public. They are members of the American Association of Zoo Keepers and are honored every July during National Zoo Keeper Week. (Courtesy Saint Louis Zoo Archives.)

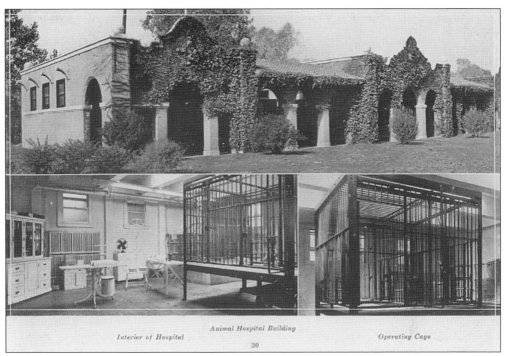

*Interior of Hospital*

*Animal Hospital Building*

30

*Operating Cage*

The Portland Cement Building, an exhibit hall left over from the 1904 World's Fair, became the Saint Louis Zoo's first veterinary hospital. According to past zoo superintendent Charles Hoessle, the animal hospital also was the location for the superintendent's office and for a commissary. Food for the animals was prepared at the site, until it was decided that such preparation should be isolated from animal treatment services. (Courtesy Saint Louis Zoo Archives.)

Lions and tigers as well as jaguars and leopards have always been a big draw attracting audiences to the Saint Louis Zoo. In the days of famous lion tamer Jules Jacot, visitors could watch breathlessly as he put his head in the lion's mouth. Such shows were phased out, with less emphasis on sensational spectacles and more on natural settings. Today's Big Cat Country, built in 1975, provides open yards complete with boulders, trees, and a waterfall. (Courtesy Saint Louis Zoo/Bryan Denning.)

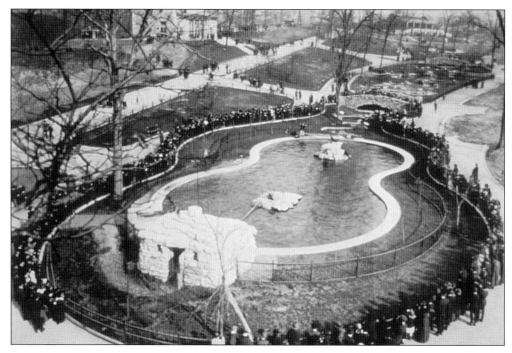

Sea lions can be extremely active and very loud. When they vocalize at full strength, they are heard around the zoo and attract a crowd. The old sea lion basin also was home to the celebrated sea elephant known as Moby Dick. The old basin has been replaced by Sea Lion Sound. One of the notable features now is the 35-foot-long underwater viewing tunnel for visitors. (Above, courtesy Saint Louis Zoo Archives; below, courtesy Saint Louis Zoo/David Merritt.)

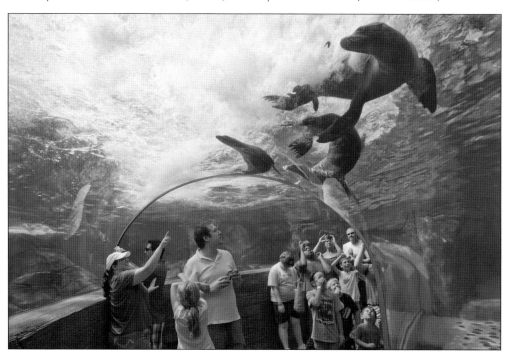

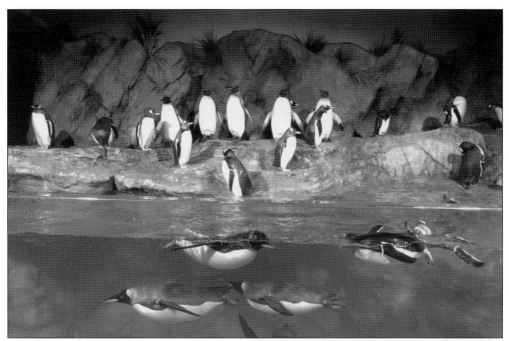

Penguins and puffins are flightless birds that have long found their way into the hearts of Saint Louis Zoo visitors. Penguins are native to the Southern Hemisphere and especially Antarctica; puffins are native to the North Atlantic and Arctic Oceans. They both have found a new home at the Saint Louis Zoo's Penguin and Puffin Coast. The old digs have been replaced by a rocky, frigid habitat that includes an underwater, walk-through viewing exhibit. (Above, courtesy Saint Louis Zoo/Gil Courson; right, courtesy Saint Louis Zoo/Roger Brandt.)

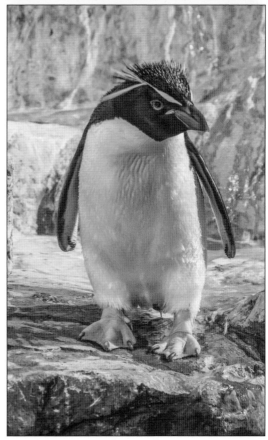

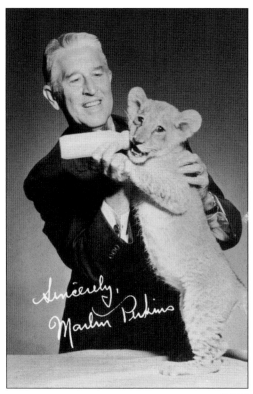

Marlin Perkins, who became the Saint Louis Zoo's second full-time director in 1962, was known throughout the world for his travels on the television show *Mutual of Omaha's Wild Kingdom*. Perkins made journeys to jungles, marshes, and deserts to teach an appreciation and respect for animals. Perkins advocated for ecology and conservation over the airwaves and at the Saint Louis Zoo until his retirement in 1970. (Both, courtesy Saint Louis Zoo Archives.)

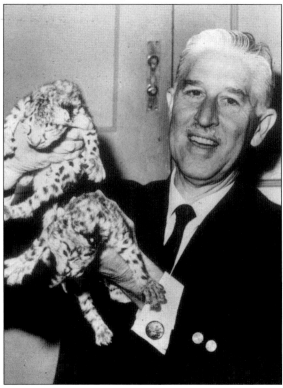

A top attraction at the Saint Louis Zoo requires a passenger ticket. The Zooline Railroad has carried more than 35 million passengers during more than five decades of operation. An early poster advertising the world-famous railroad notes it is the best way to travel for stops at the Elephant House, the Lion House, and Vierheller Station. The train engine's bells and whistles can be heard in Forest Park outside the zoo. (Courtesy Saint Louis Zoo Archives.)

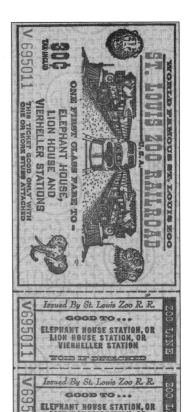

The Saint Louis Zooline passenger train made its first trip through the zoo on August 30, 1963, and has been a reliable means of travel ever since. The train is powered by one-third-size replicas of the original *C.P. Huntington*, a steam locomotive from 1863 known as the "Iron Horse." According to zoo officials, the Zooline employs 30 engineers, 5 dispatchers, and 50 conductors. (Courtesy Saint Louis Zoo.)

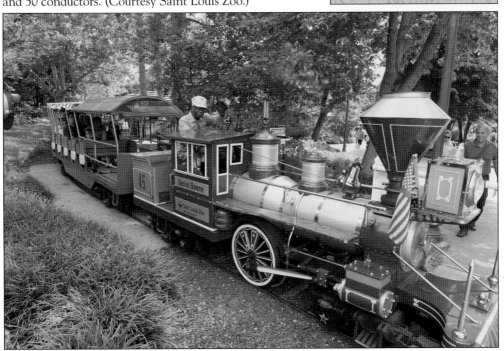

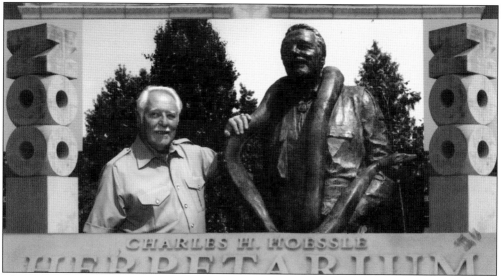

Charles "Charlie" Hoessle came to the Saint Louis Zoo in 1963 because of his love for snakes, and he was naturally given the position of reptile keeper. Just over four decades later, the zoo named the herpetarium, or reptile house, in honor of Hoessle. Also in 2005, a life-size statue of Hoessle, draped with a boa constrictor, was unveiled at the herpetarium. Hoessle rose to become director of the zoo from 1982 to 2002. Hoessle was also the host of *Saint Louis Zoo Show*, a weekly TV program that aired from 1968 to 1978. (Courtesy Charles Hoessle.)

In the early years of the Saint Louis Zoo, live insects were kept in the herpetarium with the snakes and reptiles. Centipedes, spiders, caterpillars, and butterflies were housed in small containers primarily for educational purposes, according to reptile expert and past zoo director Charles Hoessle. In 2000, a new 9,000-square-foot insectarium opened at the zoo with educational exhibits as well as facilities for breeding and researching invertebrates. (Courtesy Saint Louis Zoo/Robin Winkelman.)

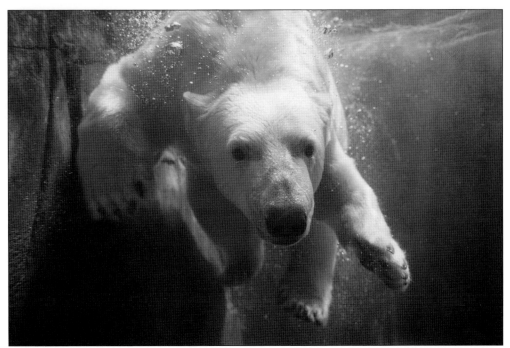

Polar bears have entertained crowds at the Saint Louis Zoo since the 1920s, but in 2009, the zoo was totally without a polar bear. The last one had been lost to liver cancer. The zoo commenced to build a new home for polar bears, and skeptics asked whether the new home would actually get an inhabitant. In 2015, the zoo opened the $16 million Polar Bear Point. Its first occupant was a bear named Kali from Alaska. The zoo has been using the exhibit, in part, to educate visitors about loss of habitat for polar bears due to climate change. (Both, courtesy Saint Louis Zoo/Ray Meibaum.)

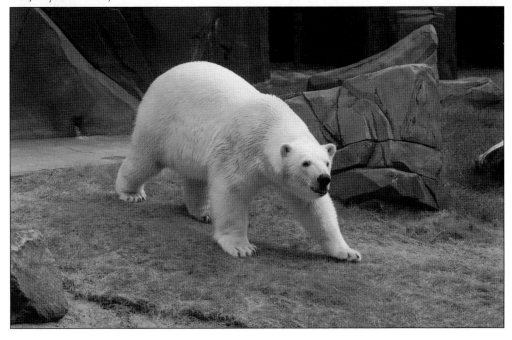

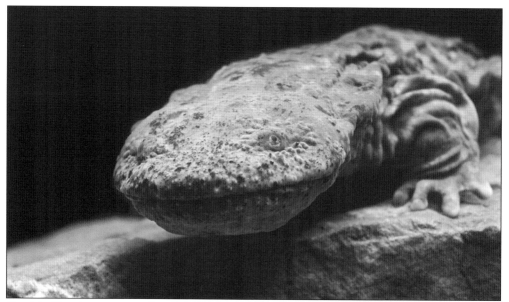

Ozark hellbenders, aquatic salamanders found in Ozark streams, have become the "poster children" for the Saint Louis Zoo's success with endangered species. Only 300 are thought to be still alive in their natural habitat today, but the Saint Louis Zoo can now show off several thousand of the critters. The zoo had its first successful breeding of hellbenders in captivity at the herpetarium in 2011. (Courtesy Saint Louis Zoo/Ray Meibaum.)

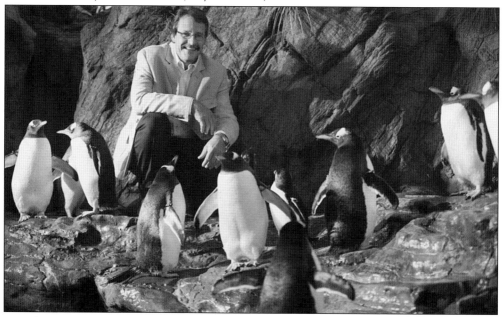

Dr. Jeffrey P. Bonner became president and chief executive officer of the Saint Louis Zoo in 2002. An anthropologist with extensive experience at other zoological institutions, Bonner has put even more emphasis on the zoo's commitment to animal preservation. Through his efforts, the zoo's Wildcare Institute was born. From the care and preservation of Armenian mountain vipers to Ozark hellbender salamanders, the Saint Louis Zoo's outreach extends far beyond the perimeter of the zoo at Forest Park. (Courtesy Saint Louis Zoo/Gregg Goldman.)

*Four*

# SAINT LOUIS
# ART MUSEUM
## ART FOR ST. LOUIS'S SAKE

One of the most magical winter scenes anywhere on the globe is that of joyous sled riders heading down a snowy Art Hill at dusk. The backdrop for this wintry wonder is a statue of King Louis IX of France, *Apotheosis of St. Louis*. Behind this namesake bronze symbolizing St. Louis is the outstanding facade of the Saint Louis Art Museum. Modeled after the Baths of Caracalla in Rome, the monumental Palace of Fine Arts was designed by architect Cass Gilbert for the 1904 World's Fair.

The Saint Louis Art Museum came to Forest Park in 1909 after being located downtown for 30 years on the northeast corner of Lucas Place (now Locust Street) and Nineteenth Street. The museum began as the St. Louis School and Museum of Fine Arts, an independent entity within Washington University. In 1901, it was agreed that the central pavilion of the Art Palace, planned for the Louisiana Purchase, would be a permanent structure and would become the new site of an art museum for St. Louis following the1904 World's Fair. Now celebrated as one of America's premier comprehensive art museums, the Saint Louis Art Museum includes more than 30,000 works of art from all cultures and time periods.

"Being in a city with French roots, it's very appropriate that the museum has a strong collection of French Impressionist and Postimpressionist art, including iconic masterworks like Monet's *Water Lilies* and Degas's *Little Dancer of Fourteen Years*," said Simon Kelly, curator of modern and contemporary art. "The Museum bought Impressionist paintings early on, acquiring major works by Manet and Monet as early as 1915, and has also built up an important collection of five Van Gogh paintings. Alongside its connection to France, the Museum has an exceptional collection of work by German Expressionist painters, notably Max Beckmann, and postwar German artists."

In addition to European and America art of the late 19th and 20th centuries, the art museum has impressive offerings in Oceanic art, pre-Columbian art, ancient Chinese bronzes, and more. The Saint Louis Art Museum has made a commitment to contemporary art with the development of the Currents series, which highlights new work by emerging artists who often embrace digital technology and new media in their artistic practice.

With its wide scope of curatorial expertise, its depth of collections, and the resources to undertake exhibits that expand art history scholarship and excite the public, the Saint Louis Art Museum now ranks among the highest in attendance of the nation's art museums. Much of that popularity is due to the physical expansion of the institution and its unique location in the heart of Forest Park.

"It is difficult to imagine the Saint Louis Art Museum anywhere other than in Forest Park, the home of more than a century of so many beloved institutions, and a treasure in its own right," said museum director Brent R. Benjamin. "The opening of the East Building in 2013 increased gallery and public space by 30 percent, with 21 new galleries for the collection and temporary exhibitions. The expansion project has also enabled the renovation of much of the Museum's iconic 1904 Main Building and the reinstallation of more than 1,450 works of art in 68 galleries. In 2015, we were able to reinforce that deep connection with the opening of the Grace Taylor Broughton Sculpture Garden, which allowed us to bring works from the Museum's collection outside its walls to create a unique and enriching experience of art in nature."

Cass Gilbert was an architect with a national reputation for bringing a classical style to museums, libraries, capitol buildings and more. His legacy in Forest Park is the Saint Louis Art Museum. This c. 1900 pencil portrait of Gilbert by F. Luis Mora reveals the seriousness of an architectural genius. (Courtesy Saint Louis Art Museum, Richardson Library Slide Archive.)

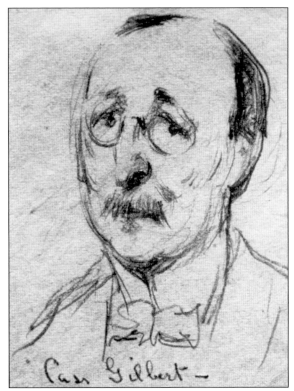

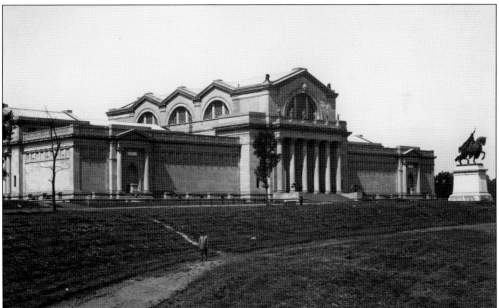

The Saint Louis Art Museum, founded in 1879 as the St. Louis School and Museum of Fine Arts in downtown St. Louis, was originally an independent entity within Washington University. The move to Forest Park was a monumental undertaking. Here is a perspective of the north facade of the City Art Museum (now Saint Louis Art Museum) as seen from the northeast in 1914. (Courtesy Saint Louis Art Museum, Museum Archives.)

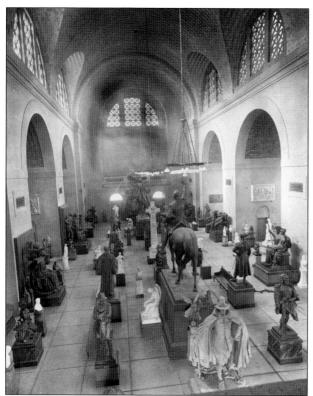

Additions, renovations, and expansions came to the Saint Louis Art Museum in the 1950s, 1970s and again with a new millennium. They have all brought a new dimension to a still-classic structure. Here is a full c. 1914–1927 view of Sculpture Hall inside the Cass Gilbert Building. (Courtesy Saint Louis Art Museum, Museum Archives.)

The Saint Louis Art Museum, originally the Palace of Fine Arts for the 1904 World's Fair, was built on a high hill in Forest Park. The steep walk to the Beaux-Arts building certainly had its rewards, such as the many works exhibited in Sculpture Hall, seen here in the Cass Gilbert Building of the Palace of Fine Arts during the Louisiana Purchase Exposition in 1904. (Courtesy Saint Louis Art Museum, Museum Archives.)

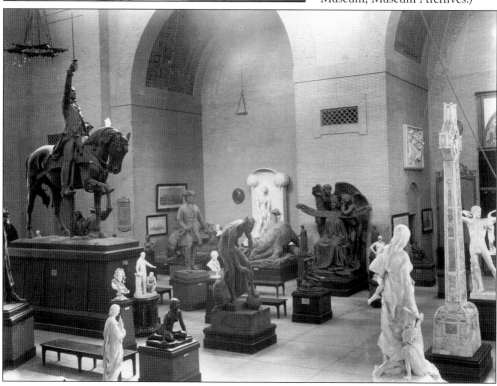

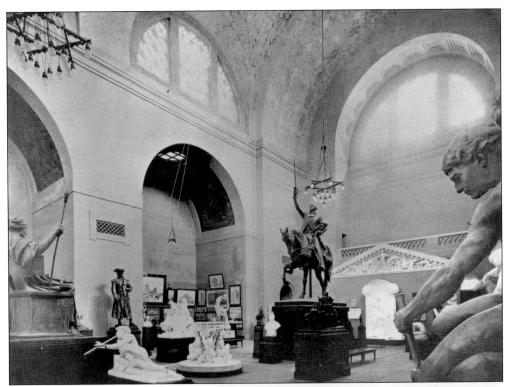

A tour of Sculpture Hall in the Cass Gilbert Building of the City Art Museum (now Saint Louis Art Museum) included ventures into the many side alcoves to appreciate works of more modest proportions. This photograph was taken about 1910. (Courtesy Saint Louis Art Museum, Museum Archives.)

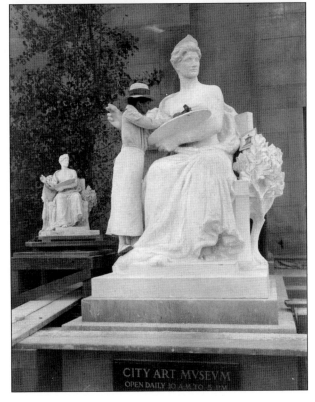

Annette Saint-Gaudens, an American sculptor who drew and modeled figures at a young age, is best known for creating sculptures of animals, young people, and fountains. Clad in a signature hat, Saint-Gaudens can be seen working on the sculpture *Painting* (160:1913) with the maquette nearby, on the north facade of the City Art Museum (now Saint Louis Art Museum). This image was captured around 1914. (Courtesy Saint Louis Art Museum, Museum Archives.)

Additions to the Cass Gilbert Building were considered as early as 1916, but the actual first addition did not arrive until the 1950s for the Saint Louis Art Museum. Preparation for construction is under way here at the south entrance of the Saint Louis Art Museum as seen from the east in August 1954. (Courtesy Saint Louis Art Museum, Museum Archives.)

The 1950s expansion of the Saint Louis Art Museum included a new restaurant, a gallery, and a long-needed auditorium. Alterations to the museum structure are viewed here during construction of the restaurant addition at the south entrance, as seen from the southeast around 1954. (Courtesy Saint Louis Art Museum, Museum Archives.)

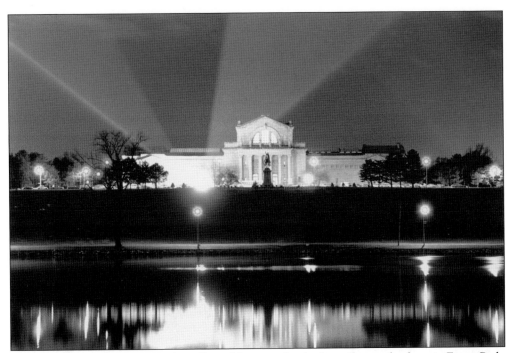

The Saint Louis Art Museum is literally and figuratively a beacon of art and culture in Forest Park, with educational programs available for a broad spectrum of the public. A portrait of the Saint Louis Art Museum at night is shown here, as it emits light from the north facade. This photograph was taken sometime around 1965–1970. (Courtesy Saint Louis Art Museum, Museum Archives.)

The Saint Louis Art Museum has a special glow at night inviting visitors for a look at some of the finest art collections in the country. The museum has occasional evening programs and is open until 9:00 p.m. on Fridays. The c. 1960 nighttime photograph here is from the north entrance of the Saint Louis Art Museum. (Courtesy Saint Louis Art Museum, Museum Archives.)

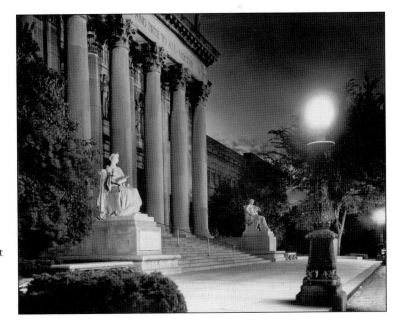

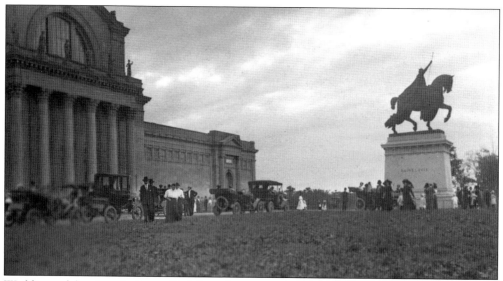

Wedding celebrations in Forest Park have been a tradition for more than a century. In this c. 1914 photograph, a wedding party disembarks in front of the City Art Museum (now Saint Louis Art Museum) and some members of the party find a spot at the base of the *Apotheosis of St. Louis* sculpture. (Courtesy Saint Louis Art Museum, Museum Archives.)

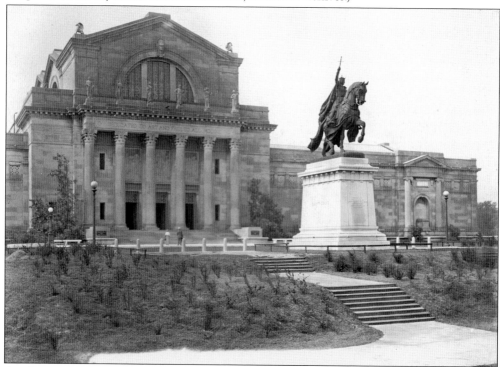

*Apotheosis of St. Louis,* a bronze sculpture of King Louis IX of France, atop a noble steed, was donated to Forest Park by the Louisiana Purchase Exposition Company after the 1904 World's Fair in St. Louis. The statue and the steps leading down to Art Hill are in front of the north facade of the City Art Museum (now Saint Louis Art Museum), as seen here around 1915. (Courtesy Saint Louis Art Museum, Museum Archives.)

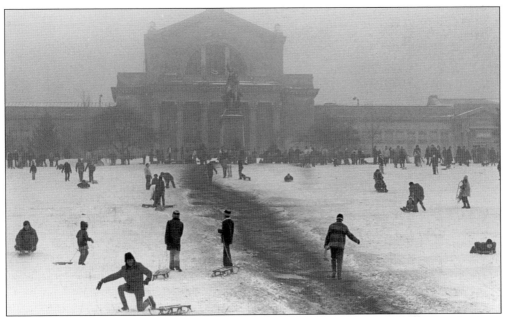

Sled riders cover the apex of Art Hill about 1973. The sledding is free, as is admission to the Saint Louis Art Museum itself, which stands behind the sledding enthusiasts on a snowy day. The Saint Louis Art Museum remains true to its commitment written in stone above the building's columns: "Dedicated to Art and Free to All." (Courtesy Saint Louis Art Museum, Museum Archives.)

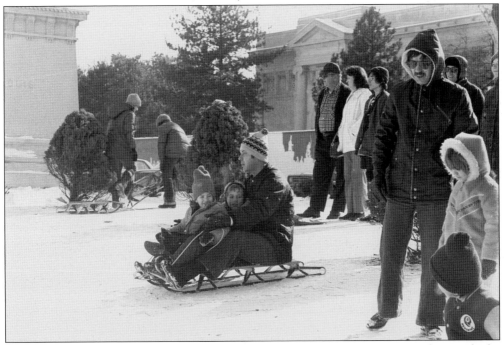

A St. Louis tradition for the young and the young-at-heart occurs every winter right outside the heavy doors of the Saint Louis Art Museum. Sled riders begin their downward journey at the top of Art Hill, as does the man in this 1973 photograph with two children aboard his sled. (Courtesy Saint Louis Art Museum, Museum Archives.)

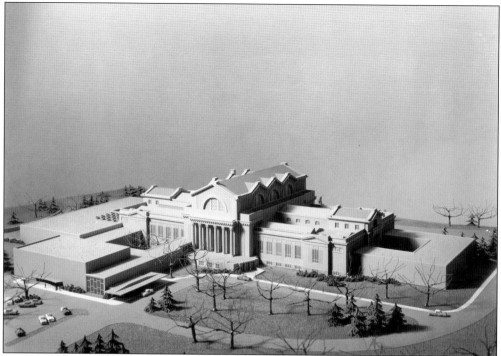

This is a scale model of the proposed City Art Museum (now Saint Louis Art Museum) expansion, made in 1959 by Mitchell Models of St. Joseph, Michigan, as viewed from a south perspective. Note the additional museum space attached to the south facade. (Courtesy Saint Louis Art Museum, Museum Archives.)

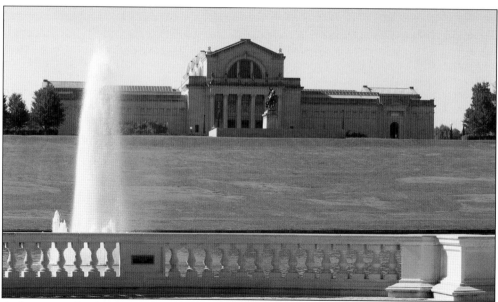

A clear view of today's Saint Louis Art Museum shows the modern version of the grand building and how it has evolved from the Palace of Fine Arts enjoyed by visitors to the world's fair in 1904. (Courtesy Holly Shanks.)

*Five*

# SAINT LOUIS SCIENCE CENTER AND PLANETARIUM
## CONSTANTLY EVOLVING

The wonders of science were very much a part of the 1904 World's Fair in Forest Park and although the fair is long gone, the wonders of science can still be found at the Saint Louis Science Center and James S. McDonnell Planetarium in Forest Park. The actual roots of the science center date back to the Academy of Science of St. Louis founded in 1856. The founders assembled a Museum of Science and Natural History, which was eventually located in a beautiful stone building in Clayton, Missouri's Oak Knoll Park in 1959. Less than five years later, science again came to Forest Park with the dedication of the James S. McDonnell Planetarium in 1962.

The planetarium drew hundreds of thousands of visitors during its first two decades with its star displays, laser shows, and telescope tours on the roof of the space-age, hyperboloid building. In the early 1980s, the city-owned planetarium grew quiet after it was sold to the science museum, which closed the facility for renovation. When it reopened in 1985, it became the Saint Louis Science Center. However, that was just the beginning of an incredible expansion. A new science building opened across from the planetarium, south of Interstate 64, on Oakland Avenue and was eventually linked with the home of the star gazers via a bridge over the highway.

The Saint Louis Science Center literally benefitted from a "space odyssey," as it increased in size by sevenfold. By 2001, the science center had evolved into a multibuilding complex and was catapulted into a distinguished category as one of the top five science museums in America. The main building on Oakland Avenue includes the OMNIMAX® Theater, a five-story, 79-foot -diameter dome theater (also known as an IMAX Dome®). The main building has hosted special exhibitions, such as *Star Trek: The Exhibition*, with space-age props, artifacts, and a full-size bridge from the USS *Enterprise*; the *International Exhibition of Sherlock Holmes*; and the *Science of Ripley's*

*Believe It or Not!* It continues to host events and special exhibitions designed to appeal to broad audiences and to spark an interest in science.

Through all its growth and popular exhibits, the Saint Louis Science Center has never lost sight of its mission to ignite and sustain lifelong learning in science and technology. As Christian Greer, chief education and programs officer for the Saint Louis Science Center notes, "Science is part of everyone's life, and through our exhibits and educational programs, we encourage people to explore the world around them and not be afraid to ask questions and seek answers. We approach learning from the point of view that we all come into this world with some innate characteristics, but we're also shaped by our life experiences and social interactions with others. We're both lifelong learners and social creatures seeking a certain kind of transformation. For the Science Center, that transformation is creating deep connections for our guests to science."

Today's Saint Louis Science Center is a wonder with its distinctive, high-tech planetarium, its bridge-tunnel over the interstate with hands-on exhibits, its one-acre outdoor and indoor exhibit on agriculture (GROW), a Makerspace exhibit that encourages exploration and invention, a Discovery Room for young learners, giant-screen films, traveling special exhibitions, the kinetic sculpture ball machine, and, of course, the voracious dinosaurs from the epic time of the T. rex.

The Saint Louis Science Center provides an in-depth museum experience for approximately one million US and international visitors each year. Of course, it also has provided St. Louis residents with indelible memories, including the sight of the planetarium building in Forest Park wrapped in a giant red bow for the holidays. More than 225 staff members and 400 volunteers now make up an expert team dedicated to learning in science and technology.

Leading that team is Bert Vescolani, president and CEO of the Saint Louis Science Center, who explains, "Science is constantly evolving, which makes it very exciting. Through our exhibits and programs we work to connect people to science in ways that resonate and make them want to learn more. We work to make science accessible and relevant to everyone's lives to help spark a continued interest in the subject and inspire future generations of scientists, astronauts, educators, problem solvers and learners."

The McDonnell Planetarium attracted its first visitors to its Forest Park site with a star show in April 1963. Attendance at the planetarium may have been bolstered during the 1960s because of the "space race" to the moon between the United States and its powerful rival, the now defunct Soviet Union. (Courtesy Saint Louis Science Center.)

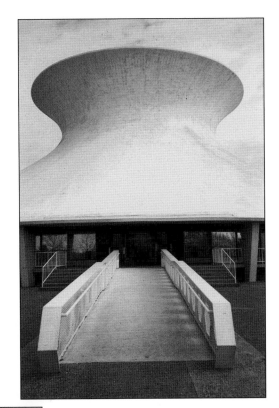

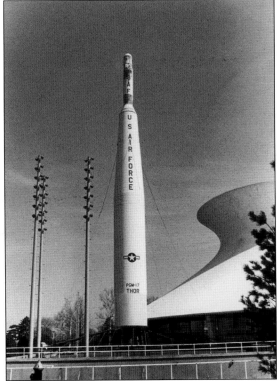

Ten years after its opening, the planetarium received an 87-foot-tall Thor rocket for display outside the building. Thor was one of the first American space launch vehicles and was modified again and again for space-age tasks well into a new century. (Courtesy Saint Louis Science Center.)

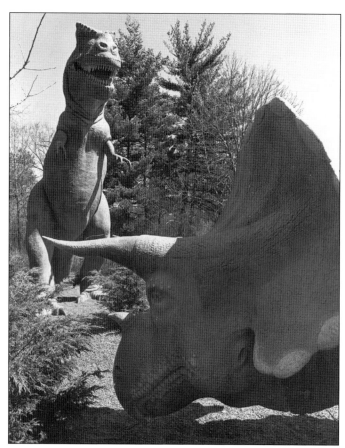

An angry Tyrannosaurus rex invaded the grounds of the planetarium in St. Louis along with a humbler triceratops. The two menacing dinosaurs thrilled children and became a major attraction for those traversing through Forest Park. (Courtesy Saint Louis Science Center.)

The dinosaurs were assembled outside the planetarium in Forest Park, north of Interstate 64. When the St. Louis Science Center expanded south of the interstate, the dinosaurs found some company. A new dinosaur diorama was built with an animated T. rex that proved more frightening than the one outside the planetarium. (Courtesy *West End Word*.)

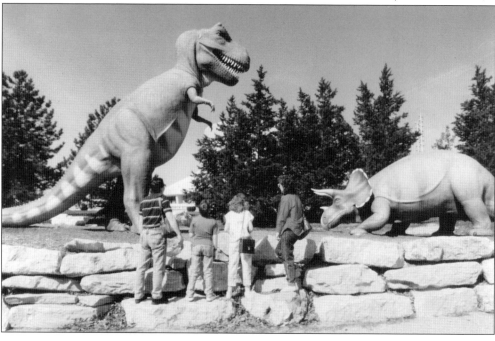

The planetarium can be seen from several highways that crisscross St. Louis and intersect at the southeast corner of Forest Park. From the windows of passing cars, the uniquely designed planetarium looks like a flying saucer that has landed in the park. (Courtesy Saint Louis Science Center.)

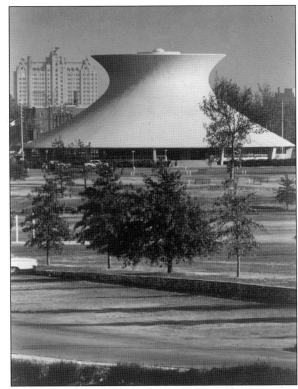

An ambitious program to expand the Saint Louis Science Center included an enclosed catwalk across Highway 40 (now Interstate 64) to link the planetarium with a new main building on Oakland Avenue. The catwalk itself is used for science learning as cars whizz by directly below it. (Courtesy Saint Louis Science Center.)

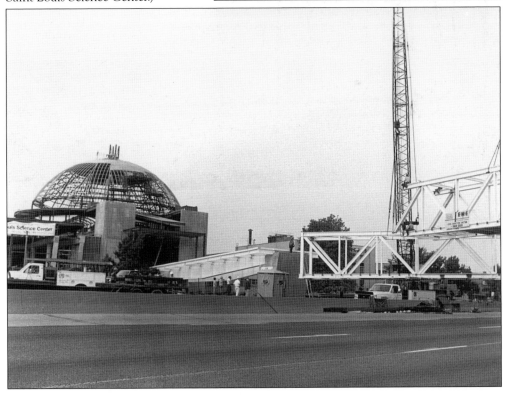

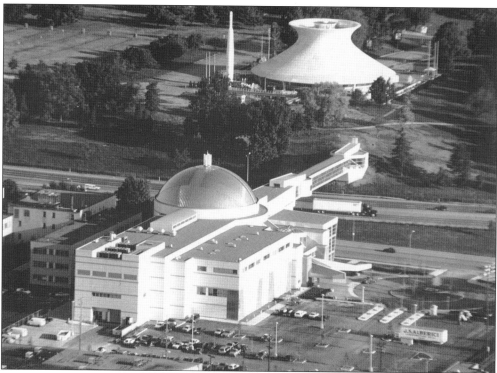

A bird's-eye view of the completed Saint Louis Science Center reveals the enclosed catwalk link to the McDonnell Planetarium in Forest Park. The huge dome atop the science building houses the OMNIMAX Theater where images are projected on a five-story, curving screen designed for an entire field of vision. (Courtesy Saint Louis Science Center.)

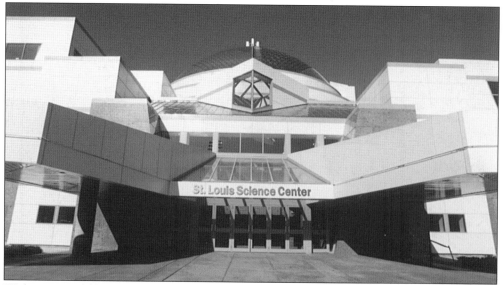

With its sevenfold increase in size, the Saint Louis Science Center became one of the nation's premier facilities, rating in the top five science centers in the United States. Its primary mission continues to center on promoting an interest and an understanding of science and technology. (Courtesy Saint Louis Science Center.)

St. Louis is recognized for its iconic 630-foot monument of stainless steel known as the Gateway Arch. A popular science exercise at the Saint Louis Science Center involves building an arch of foam bricks, which demonstrates basic engineering principles. (Courtesy Saint Louis Science Center.)

There is no end to the science fun for youngsters at the planetarium in Forest Park and across the catwalk at the greatly expanded Science Center. Children get high priority at the Saint Louis Science Center with more than 700 hands-on exhibits that include special activity rooms. Even preschool children are catered to with programs for problem solving and activities for the development of social skills. Inquisitive children can learn about their world in the Discovery Room and Life Science Lab, at the Ecology and Environment Gallery, and more. (Courtesy Saint Louis Science Center.)

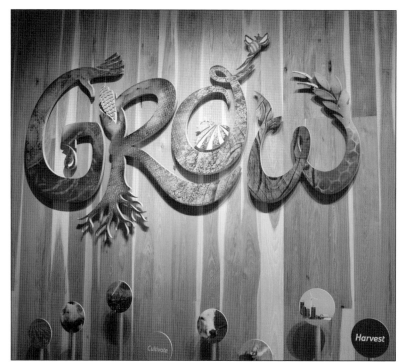

The new GROW exhibit at the Saint Louis Science Center opened in June 2016. The exhibit, complete with chickens, vegetable gardens, and tractors, tells the modern-day story of how food makes it from the farm to the dinner table. (Courtesy Holly Shanks.)

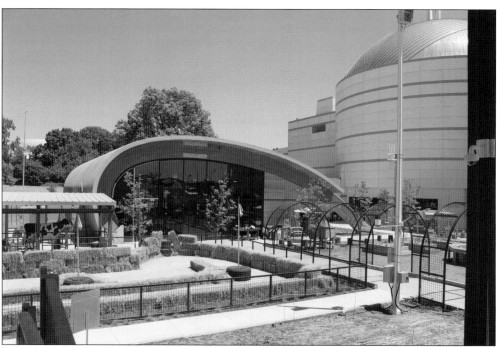

The interactive GROW exhibit is a permanent addition to the science facility The Saint Louis Science Center determined that now is the time to bring the story of agriculture to its visitors because of a large "food movement" happening in the St. Louis region and across the country. (Courtesy Holly Shanks.)

# Six

# MEET ME AT THE MUNY
## BEST OF OUTDOOR THEATER

Just 10 years after the 1904 World's Fair, a massive production celebrating the founding of St. Louis was staged in Forest Park. *The Pageant and Masque* was performed on Art Hill to audiences of 100,000 per night. The roots of the St. Louis Municipal Opera, or the Muny, were planted. The production inspired a 1916 tribute to the tercentenary of Shakespeare's death. An outdoor performance of *As You Like It* was planned for a location with a wide, flat surface with mature oaks and other trees forming a dramatic backdrop.

Thanks to the popular success of the Shakespeare offering, Giuseppe Verdi's grand opera *Aida* was billed for 1917. Two years later, Mayor Henry Kiel assembled the St. Louis Municipal Opera Committee, and soon a tradition of yearly entertainment in an outdoor setting was established for St. Louis. The Muny flourished, and technical improvements in the way of sound and lighting, as well as audience comforts, were added year by year.

By 1930, the country was feeling the pinch of the Depression, although in a Muny program, the theater declared itself "Depression-proof," with its first-rate Shubert productions from New York. World War II presented its own challenges, but when the 1950s dawned, an evolution in musicals was in the air. The Muny's first production, *Oklahoma!*, arrived in 1954 and the 1955 season was virtually dedicated to Broadway's new golden team of Rodgers and Hammerstein. In addition to *Rodgers and Hammerstein in Concert*, *Carousel*, *Allegro*, *The King and I*, and *South Pacific* all had their Muny premieres that season.

The 1960s saw a host of newcomer productions taking over, and more St. Louis residents acquired the habit of buying season tickets to the Muny. They were treated to Lerner & Loewe's *Camelot* and *My Fair Lady* and Meredith Willson's *The Unsinkable Molly Brown* and *The Music Man*. In 1963, a young fellow named Stephen Sondheim became known to St. Louis audiences through two important musicals: *Gypsy* and *West Side Story*.

Throughout the '70s and '80s and into the present, the Muny lineup has been consistent with great productions and a Forest Park setting that cannot be duplicated. "Poets and publicists have always praised the incomparable beauty of the Muny home, and as one who has spent many summer evenings there, I agree," said Denny Reagan, president and CEO of the Muny. Native St. Louisan and character actress Mary Wickes put it simply: "The Muny on a warm summer night . . . full moon . . . that great orchestra playing and a golden-voiced tenor singing. Trust me. It's as close to heaven as some of us will get."

With the new millennium, current executive producer Mike Isaacson took the helm in 2012 and has led the Muny to what some have called a new golden age. Devising seasons that combine classic musicals with Broadway's latest and greatest, Isaacson has elevated the production values to new levels, brought state-of-the-art innovations to the stage and auditorium, and showcased the brightest talent available anywhere in America.

"The Muny remains a powerful symbol for the greatness of St. Louis," said Isaacson. "As the Muny turns the corner into its second century, we're committed to creating productions of the scope and style and joy that cannot be seen anywhere else in the country, if not the world. It's a theatre with a grand tradition and a great future."

The site of today's Muny was decided upon in 1916, when New York actress-producer Margaret Anglin toured Forest Park with St. Louis mayor Henry Kiel and parks commissioner Nelson Cunliff. Their choice for the outdoor theater continues to please audiences a century later. In this image, there is a man standing on what is now center stage. (Courtesy the Muny Archives.)

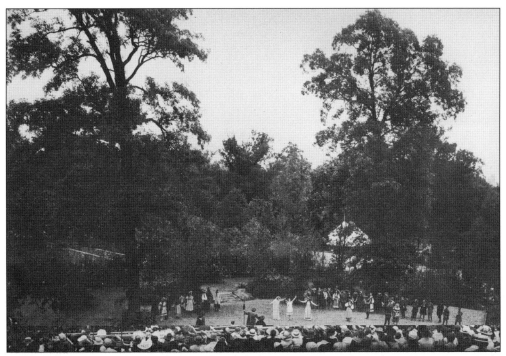

*As You Like It*, a pastoral comedy by William Shakespeare, was performed in 1916 in Forest Park. Rough-hewn planks were laid in the audience to form tiers for watching the performance. The show was well-received in St. Louis, both critically and popularly. (Courtesy the Muny Archives.)

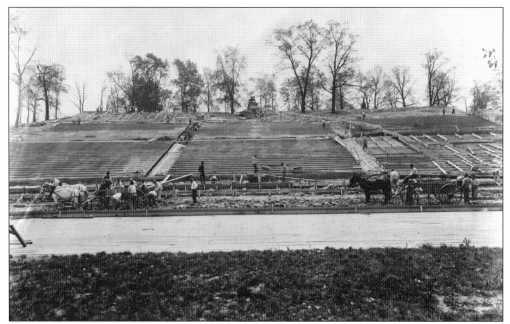

In 1917, a production of the grand opera *Aida* was chosen as the entertainment for a convention of the Associated Advertising Clubs of the World. The Advertising Club of St. Louis agreed to pay a portion of the cost to make the Forest Park location a permanent open-air theater. (Courtesy the Muny Archives.)

Between 1916 and 1930, the Municipal Theatre Association often played home to late-summer *Playground Pageants*. Children from all over the St. Louis area would rehearse a scene or dance from a play. They would come together and perform their show for friends and family. (Courtesy the Muny Archives.)

The St. Louis Fashion Pageant was a major late-summer event designed to showcase the fall and winter fashion trends for St. Louis. These were elaborate events staged by the St. Louis Style Show Committee. The 1923 Fashion Pageant featured the Fountains at Versailles and an ice-skating rink. (Courtesy the Muny Archives.)

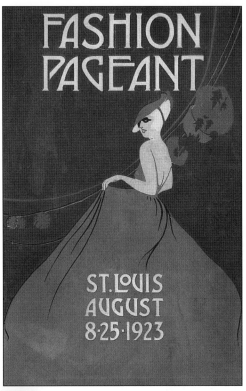

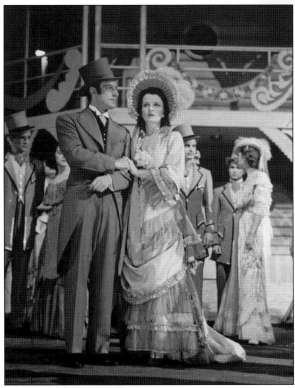

In the face of the Depression, the Municipal Theatre Association engaged the Shubert Brothers to produce in St. Louis. From 1930 through 1934, the New York impresarios brought the latest Broadway blockbusters to the Muny, including the musical *Show Boat*. (Courtesy the Muny Archives.)

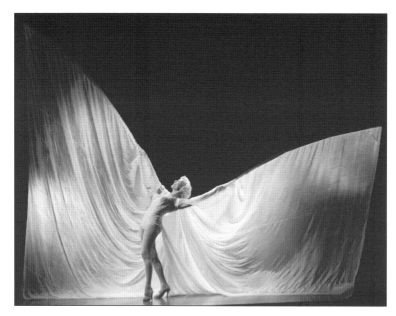

Mira Nirska captivated audiences around the world with her ethereal dance as a human butterfly. Madame Nirska's flapping wings of shiny silk transformed her into an exotic ballerina of delicate beauty. She made several spectacular Muny appearances between 1927 and 1952. (Courtesy the Muny Archives.)

Gene Kelly kicks up his heels in the Muny's 1974 production of *Take Me Along*, a musical based on the Eugene O'Neill play *Ah, Wilderness!* The energetic Kelly reportedly wanted his children to see "the old man" onstage, as opposed to "just" watching him in the movies. (Courtesy the Muny Archives.)

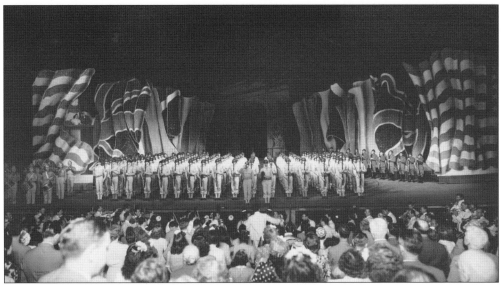

During World War II, performers at the Muny expressed their patriotism in the way they knew best—musically and on a grand scale. In 1943, theatrical "recruits" from Jefferson Barracks in south St. Louis offered a thrilling spectacle in the production *Sons O'Guns*. (Courtesy the Muny Archives.)

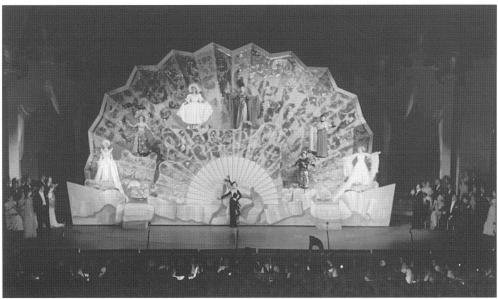

The elaborate sets of the 1940s echoed the lavish Follies-type entertainment found on Broadway at the time. Designer Watson Barratt created this set for *Roberta* in 1949. It measured 43 feet wide by 22 feet high at the center and featured women of the ensemble as living decorations on a massive fan. (Courtesy the Muny Archives.)

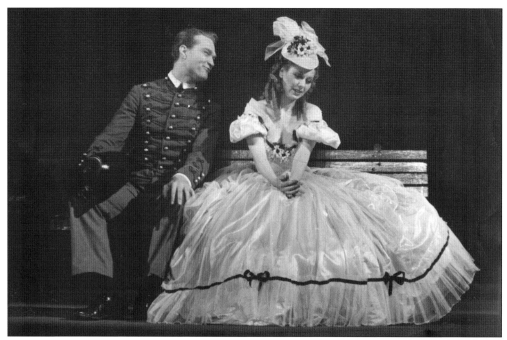

A very young Richard Bernard "Red" Skelton made his Muny debut in a 1938 production of *Gentlemen Unafraid*. The mercurial entertainer was best known for his radio and television acts between 1937 and 1971, in which he played a variety of characters. (Courtesy the Muny Archives.)

The Shubert Brothers sent a promising young performer to St. Louis to gain a little "polish." Archie Leach spent a summer at Forest Park as a resident baritone at the Muny before making a name for himself as a very polished Cary Grant. (Courtesy the Muny Archives.)

Television's Lily Munster, the odd and comical wife of Herman Munster, appeared at the Muny in 1972 in Stephen Sondheim's *Follies*. Yvonne De Carlo was found in the backstage cantina wearing a fur coat in July—about what one would expect from the matriarch of the Munster family. (Courtesy the Muny Archives.)

Betty White made three appearances at the Muny in Forest Park, beginning with the show *Take Me Along* in 1961. Two years later, she appeared as Anna Leonowens in *The King and I*. She is pictured here in the 1966 production of *The Bells Are Ringing*, a musical about Ella, who works for an answering service. (Courtesy the Muny Archives.)

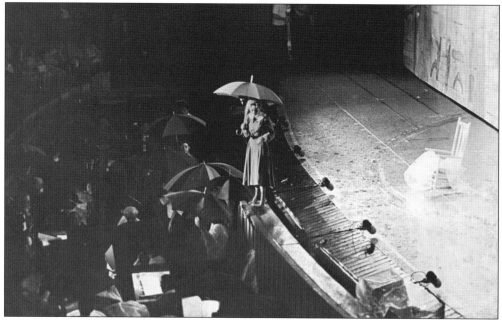

An occasional problem for outdoor theater is bad weather. Rain interrupted the performance of Debbie Reynolds in *Irene* in 1973. The undaunted actress grabbed an umbrella and entertained the Muny audience throughout the rain delay. (Courtesy the Muny Archives.)

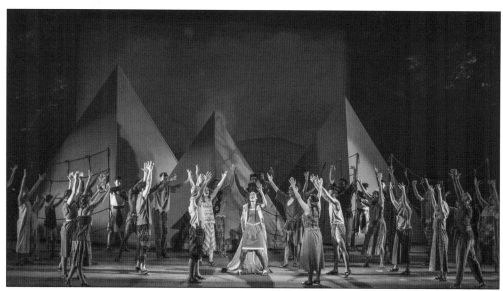

Michelle Williams played the title role in the 2016 Muny extravaganza of Elton John and Tim Rice's *Aida*. The Grammy-winning singer with the group Destiny's Child has starred in *Aida* on Broadway. Williams also has appeared in *The Color Purple*, *Chicago*, and *Fela!* on Broadway. (Courtesy the Muny/Phillip Hamer.)

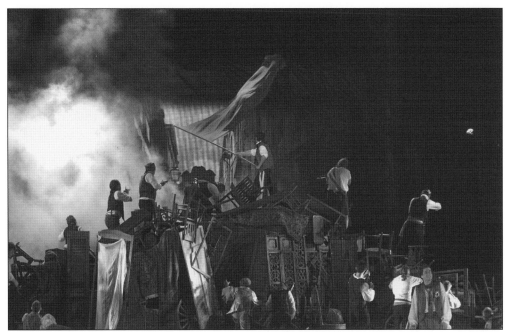

With a running length of three hours, the epic *Les Misérables* came to the Muny stage in 2013 with moving musical offerings that soared into the night sky. Adapted from the 1862 novel by Victor Hugo, *Les Misérables* brought the spirit of the French Revolution to Forest Park. (Courtesy the Muny/Jim Herren.)

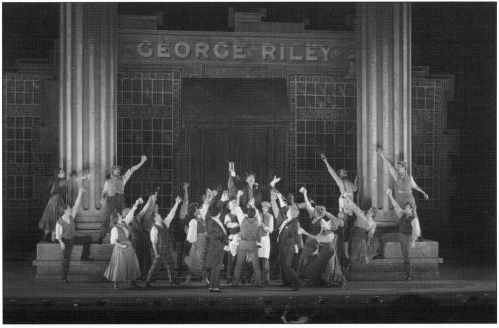

Not seen at the Muny since 2008, Alan Jay Lerner and Frederick Loewe's classic *My Fair Lady* came for an encore in 2015. The musical about a snobbish phonetics professor, who takes a wager that he can transform a Cockney flower girl and make her acceptable for high society, could only be described as "loverly." (Courtesy the Muny/Phillip Hamer.)

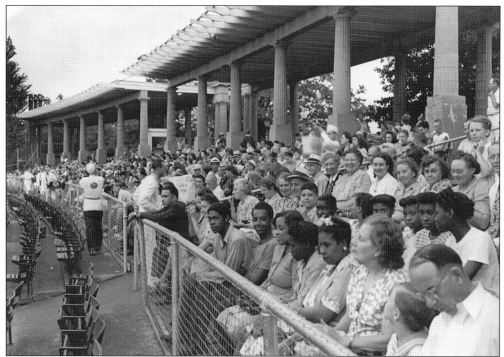

The musical *Hit the Deck* appeared at the Muny for four different seasons and was the featured production one summer for Cardinal Family Night at the Opera. The audience included family members of St. Louis Cardinals standouts, including Stan Musial, Joe Medwick, and Terry Moore. (Courtesy the Muny/*St. Louis Post-Dispatch*.)

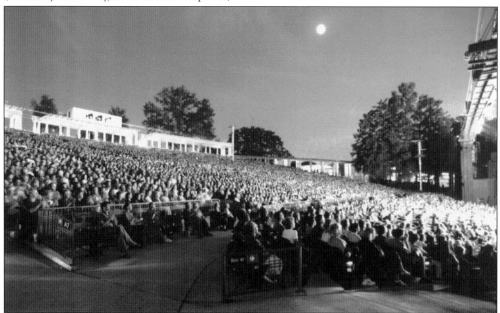

There is nothing quite like a full house under a full moon at the Muny in Forest Park. Actress Mary Wickes, who played Katie in *Meet Me in St. Louis* in 1960 said a clear summer night at the Muny is "as close to heaven as some of us will get." (Courtesy the Muny/Jim Herren.)

Arborists have been called upon to inspect the huge trees flanking the Muny stage for decades. In 2002, the last of the giant oaks gave up the spirit to age and disease. Actually, their spirit was sustained as some of their wood was cured and used for the Muny's board table—an example of sustainability. (Courtesy the Muny/*St. Louis Post-Dispatch*.)

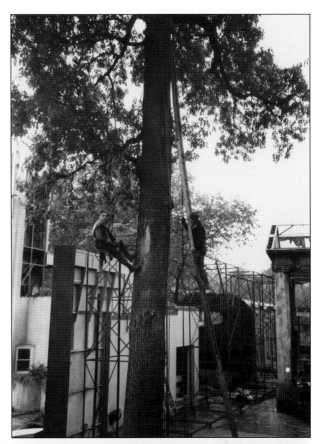

Audiences at the Muny can look skyward during many productions and find interesting cloud formations or the twinkling of stars surrounding a waxing moon. Sometimes, they can look skyward and see actors and actresses flying over the stage in productions such as *Peter Pan* or *The Wizard of Oz*. (Courtesy the Muny/Phillip Hamer.)

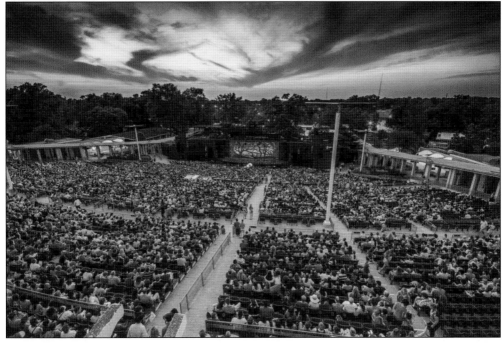

The Muny is located at 1 Theatre Drive in Forest Park and draws tens of thousands of people for production seasons that run every year from mid-June to mid-August. The Muny is short for the Municipal Theatre Association of St. Louis, and its theater seats 11,000 people. About 1,500 seats in the back nine rows are free on a first-come-first-served basis. (Courtesy Holly Shanks.)

The rotunda at the St. Louis Municipal Opera has a charm and grace more typical of elaborate indoor theaters. Its stately charm is probably overlooked by most theatergoers as they rush to find their seats for *Fiddler on the Roof*, *West Side Story*, or *42nd Street*— all musicals that have seen multiple productions at the Muny. (Courtesy Holly Shanks.)

## Seven

# Sports Mecca
## Skating, Tennis, Golf, and More

From the beginning, with its formal opening in 1876, Forest Park has served the sports and recreation needs of St. Louis residents. Outdoor enthusiasts came to ride their horses on park trails and hike its forests. They came to catch sport fish in the park's streams and to compete in athletic events. Schools, churches, and civic organizations took out park permits for their activities. More than 5,000 members of the Turner gymnastic societies came to the park in 1891 for days of games and competitions.

By the early 1900s, amateur athletic associations were using different corners of Forest Park. Baseball diamonds, tennis courts, and a nine-hole golf course found homes in the sprawling park. St. Louis commissioner of parks Dwight F. Davis encouraged such uses of the new city resource, saying in 1911 that a modern city park system should have as its purpose "the raising of men and women rather than grass and trees." Davis and his successors felt the park was an excellent location for new immigrants to find paths to assimilation into the American experience. They also felt that the outdoor recreation and organized sports were good for the soul; athletics instilled values of hard work and adherence to rules and practice regimens as well as team spirit.

Dwight Davis was an impressive athlete in his own right. He was the national outdoors tennis champion from 1899 to 1901 and during his time on the court donated a trophy for a new tennis championship to be known as the Davis Cup. He offered as many as 30 tennis courts in Forest Park for municipal leagues after World War I. In 1966, the nonprofit Dwight Davis Tennis Center opened and today is among the crown jewels of outdoor athletic sites in Forest Park, with 19 courts and an array of offerings for diverse patrons. Members and visitors now play in tournaments, take lessons from a professional staff, attend summer camps, and assist at special events.

Golf has always had three seasons in Forest Park, but golfers have been known to venture out on the "best city golf course in Mid-America" on warmer days on either side of the Winter Solstice. The Norman K. Probstein Golf Course in Forest Park was originally built as a nine-hole facility in 1912. After Scotsman Robert Foulis completed those original nine holes, a second nine-hole course was added the following year and the final nine was completed in 1915. The courses at Forest Park have hosted numerous golf events in the decades since, including the 1929 National Public Links Championship. The courses underwent a complete redesign at the turn of the century, and the work by Hale Irwin was completed in 2004. Located on the west side of

the park, the award-winning clubhouse offers beautiful views of the fairways and greens as well as surrounding park attractions.

Another shining gem for more wintry recreation in Forest Park is the Steinberg Skating Rink, which was made possible thanks to a 1944 bond issue and a generous gift to the park from the Mark C. Steinberg Charitable Trust. The rink opened in 1957 to an opening crowd of more than 2,500. By December, more than 100,000 skaters had used the facility and attendance was especially strong in years to come during school Christmas vacations. In succeeding years, Steinberg offered ice-skating instruction, family hours, moonlight sessions, and more. As the largest outdoor ice-skating rink in the Midwest, Steinberg Skating Rink in Forest Park now offers more than 27,600 square feet of frozen fun every winter season.

In addition to a public skating rink, updated golf courses, and a tennis facility with lots of tradition, Forest Park has been the site of such activities as cricket, rugby, soccer, softball, baseball, boating, fishing, jogging, and bicycling. Boating and fishing deserve special mention due to their long history dating back to the park's inception. In the early years, anglers fished in the River des Peres that once meandered through the park. Shortly after World War II, the park promoted children's fishing derbies and offered free "hook, line, sinker and bamboo pole" for each child. Today, fishing is permitted in Forest Park's lakes and lagoons with a permit. Boating has taken place in Forest Park since 1876, and today, the park boasts a new, year-round boathouse facility.

An archer stretches his bow at the range in sight of the St. Louis Planetarium in the southeast quadrant of Forest Park. St. Louis Archery Club members sponsor competitions in the park. In 1967, the National Archery Association held its championship tournament in Forest Park. (Courtesy State Historical Society of Missouri, St. Louis.)

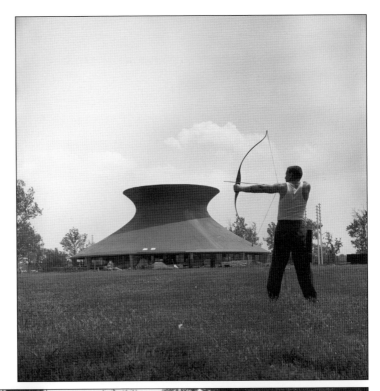

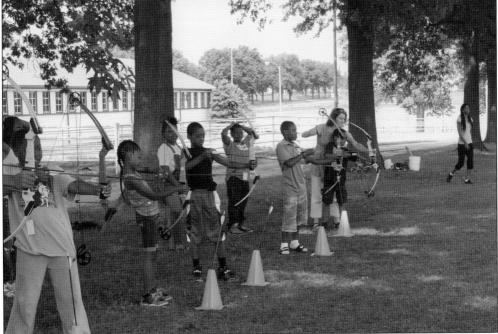

Archery continues to thrive in Forest Park and has since the 1920s when the St. Louis Archery Club was founded. In the late 1930s, the club began tournaments that attracted dozens of archers from ages 8 to 18. Tournaments sponsored by department stores like Stix, Baer & Fuller drew young Katniss Everdeens from more than 30 schools. (Courtesy Forest Park Forever.)

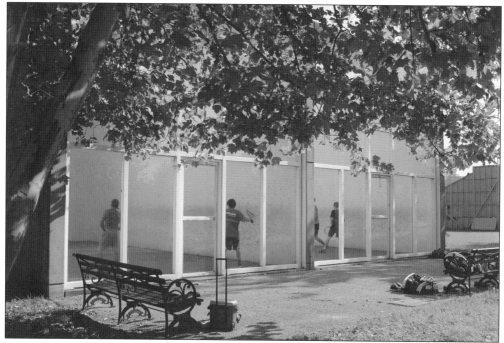

Racquetball and handball have been played in Forest Park for decades. Dwight Davis introduced many such recreational activities as city park commissioner from 1911 to 1930. Players from around St. Louis now keep the courts busy, including the members of the Forest Park Handball Club (FPHC), one of the oldest clubs in the country. (Courtesy Holly Shanks.)

Forest Park's handball courts are in constant use from early spring until late fall. Although most St. Louis residents seek their physical activity in the indoors of a fitness center in the winter months, the heartiest members of the Forest Park Handball Club (FPHC) say they will play when the temperature is 20 degrees, as long as there is no snow falling or icing. (Courtesy Holly Shanks.)

Outside Busch Stadium in St. Louis, the fans meet at the Stan Musial statue. Outside the ball diamonds at Boeing Aviation Field in Forest Park, players and fans meet near a youthful, bat-wielding statue of bronze. The diamonds in Forest Park are in great demand during the summer months. (Courtesy Holly Shanks.)

It is inevitable that the town that hosts the champion St. Louis Cardinals will maintain plenty of baseball and softball diamonds in its premier park, Forest Park. The Boeing Aviation Field at Forest Park offers four baseball diamonds and four softball diamonds. For a brief time in 1920–1921, the location served as the runway for airmail service between St. Louis and Chicago. (Courtesy *West End Word*.)

Rental boats have plied the waters of Forest Park since before the 1904 World's Fair. Leisurely boating through the park has been a traditional pastime for St. Louis residents for decades. In the 1930s, electric boats made some waves and were a popular attraction. (Courtesy State Historical Society of Missouri, St. Louis.)

Rowboats of the 1870s have been replaced by today's paddleboats, which are available for rental from the Boathouse in Forest Park. The Boathouse advertises "sentimental journeys" on park waters, where one is likely to encounter ducks, heron, geese, kingfishers, turtles, and schools of fish. (Courtesy Holly Shanks.)

Hikers and bikers find everything they need with the crisscross of trails winding throughout Forest Park. The main trail follows the park's perimeter. A trail on the park's southern boundary passes the south entrance of the Saint Louis Zoo and runs through Kennedy Forest, while another scenic trail near the eastern boundary offers views of Steinberg Skating Rink, park lakes, and the planetarium. (Courtesy Holly Shanks.)

Towering trees are a part of the wonder of Forest Park and offer much-needed shade in St. Louis summers. The park's tree canopy has recovered from clear-cutting necessary to make way for the 1904 World's Fair, as well as from the ravages of tornadoes and fierce winter ice storms. (Courtesy Holly Shanks.)

Since 1897, the game of golf has been played in Forest Park. Golfers of a century ago, however, could not enjoy all the comforts of a clubhouse. Built in 2002, the golfers' clubhouse in Forest Park offers pristine views overlooking the golf course, an adjacent lake, and waterfall. (Courtesy Holly Shanks.)

Forest Park's Norman K. Probstein Golf Course is renowned as the "Best Golf Course in Mid-America." Scotsman Robert Foulis built a nine-hole facility in 1912, and the tradition began in earnest. Today, Forest Park offers hackers and professionals access to three nine-hole courses. (Courtesy Holly Shanks.)

No account of the recreational opportunities in Forest Park is complete without a respectful acknowledgement of Dwight Davis, the famous St. Louis park commissioner from the early 1900s. After several years at work, he organized park competitions in baseball, soccer, tennis, golf, and more. Davis was an amateur athlete in his own right and was the national outdoor men's tennis doubles champion from 1899 to 1901. In 1901, Davis contributed a trophy for a new tennis tournament, which became known as the Davis Cup. (Courtesy Missouri History Museum, St. Louis.)

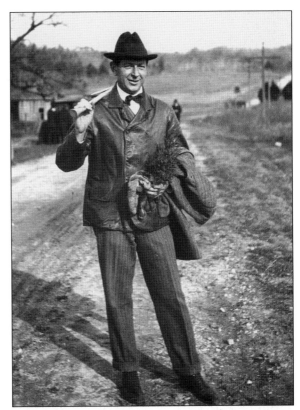

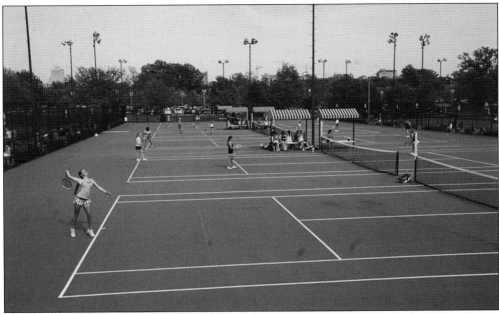

Forest Park's Dwight Davis Tennis Center officially opened in June 1966 with the US hard-court championship of professional tennis. The championship was actually preceded by a celebrity, exhibition doubles match won by St. Louis tennis star Earl "Butch" Buckholz Jr. and actor James Franciscus. (Courtesy *West End Word*/Diana Linsley.)

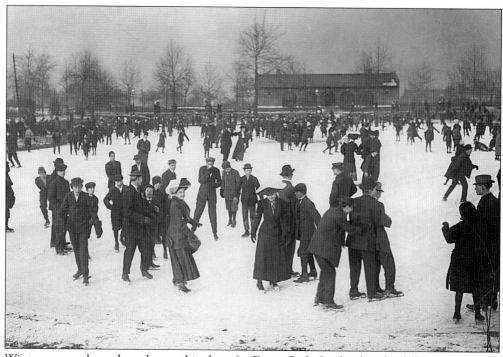

Winter sports always have been a big draw for Forest Park. In the decades following the 1876 dedication of the park, its many lakes drew skaters ready to try out their blades. Torches were used to light up the lakes for night skating, and park employees smoothed the ice with wire brushes. (Courtesy State Historical Society of Missouri, Columbia.)

Steinberg Skating Rink was the dream of the widow of a St. Louis investment banker, Mark C. Steinberg. She admired the ice rink in New York City's Central Park on visits there and made a large donation for such a facility in Forest Park. The rink has hosted tens of thousands of skaters since opening in November 1957. (Courtesy Missouri History Museum, St. Louis.)

In 1945, children under the age of 16 were allowed to fish in certain park areas during summers. The age restrictions were removed in 1972. The Missouri Department of Conservation cosponsors WOW St. Louis, a program that empowers individuals with outdoor recreation skills. Here, a young WOW participant fishes during the intro to fishing class held at the educational lakes by the hatchery building. (Courtesy Missouri Department of Conservation/Dan Zarlenga.)

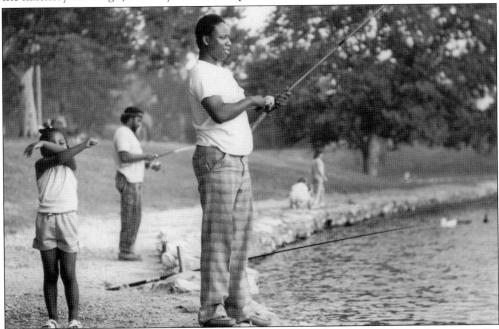

Before there was an official Forest Park, fishing was enjoyed on the area's lakes and streams. The River Des Peres once flowed through the park providing prime fishing for anglers. The tradition of fishing in Forest Park continues today. (Courtesy *West End Word.*)

The Forest Park WOW program campouts are cosponsored by the Missouri Department of Conservation. The idea is to introduce families to assembling and sleeping in tents and to enjoy outdoor breakfasts at the dawn's early light. Campout events in Forest Park provide a unique urban experience in the great outdoors. (Courtesy Missouri Department of Conservation/Dan Zarlenga.)

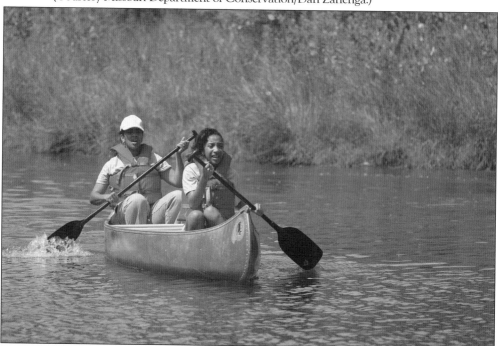

Campout weekends include instruction on such activities as canoeing, fishing, archery, geocaching, orienteering, and more. The Missouri Department of Conservation finds Forest Park to be ideal for its campout weekends because it has all the amenities for a full recreational program. (Courtesy Missouri Department of Conservation/Dan Zarlenga.)

# *Eight*

# FOREST PARK HAPPENINGS
## BALLOONS AND TUNES,
## KITES AND BITES

Happenings are described as partly planned—and partly improvised—unusual events that typically involve some variety of artistic, theatrical, or wondrous experience. In Greater St. Louis, a certain location for finding most memorable happenings has always been Forest Park. Many of the happenings have involved the aeronautical wizardry of airplanes, hot-air balloons, and homebuilt, customized kites.

Forest Park hosted a celebratory aeronautical happening in June 1927 when thousands of St. Louis residents welcomed back Charles Lindbergh after his nonstop flight from New York City to Paris. The young pilot had lived in St. Louis and the first nonstop transatlantic trip in world history was made possible with financing from St. Louis businessmen. Lindbergh buzzed the roaring crowd in his *Spirit of St. Louis*. After flying over Forest Park, he spoke at a podium on Art Hill and hung a wreath on the statue of St. Louis in front of the Saint Louis Art Museum.

Lindbergh's 1927 air visit to Forest Park after his *Spirit of St. Louis* feat is now memorialized in the St. Louis History Museum. Aeronautical magic of another sort took place 20 years earlier when nine gas balloons took off from the site of the Aero Club in Forest Park. Thousands cheered on the nine air balloon contestants in a race for the James Gordon Bennett Cup. The cheering in Forest Park for balloonists has not stopped. The Great Forest Park Balloon Race was held intermittently in the 1970s and is now an annual festival in the fall. With more than 70 entrants and 130,000 spectators, the race is the largest single-day balloon race in all of America. The balloon race is preceded by "Balloon Glow Night," a fireworks show and a concert by the St. Louis Symphony.

Music that fills the air in Forest Park during the fall can be classical, but it also can include funk, reggae, indie-rock, alternative country, soul, hip-hop, R&B, folk, and jazz. The LouFest Music Festival has become a tradition that features four stages with alternating performances. LouFest has been voted as St. Louis's "Best Music Festival" six years in a row. On a two-day weekend in September, the festival has drawn more than 150,000 music fans to Forest Park's Central Fields.

Another proven crowd-pleaser happening in Forest Park is the Shakespeare Festival St. Louis with performances in Shakespeare Glen beginning in late spring. Over a score of years, the festival dedicated to the Bard of Avon has attracted more than 670,000 people to its annual main

stage show. More than 290,000 students have been introduced to the likes of *Hamlet*, *Antony and Cleopatra*, and *Othello* in the great outdoors of Forest Park. It is not unusual for the performers to make their way through the audience before a show to do a 60-second Shakespeare Act, some acrobatic tricks, or perhaps to swallow fire.

The thought of eating fire probably gives the average person a bad case of heartburn. There is no cause for that in Forest Park, because it is a garden spot for good food. In the early years, the park was home to the Forest Park Restaurant touted by proprietor C.W. Herbert and located in the Old Farmhouse Restaurant in 1881. Herbert insisted the restaurant had "prices not above those of first-class city restaurants." In more recent times, Forest Park diners have had their choice of first-class fare at such locations as Bixby's in the History Museum, Panorama Restaurant in the Saint Louis Art Museum, or the Boathouse Restaurant on Post-Dispatch Lake.

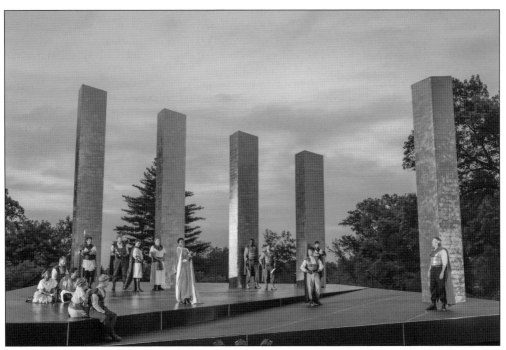

Shakespeare Festival St. Louis offers a novel way to experience the classic plays of the world's most famous bard in an outdoor setting. Evening performances are held at Shakespeare's Glen in Forest Park in a large grassy area near the intersection of Government Drive and Fine Arts Drive, not far from the Saint Louis Art Museum or the Saint Louis Zoo. (Courtesy Shakespeare Festival St. Louis/J. David Levy Photography.)

# SHAKESPEARE FESTIVAL ST.LOUIS

The logo of Shakespeare Festival St. Louis is familiar far beyond the confines of the park. The festival in Forest Park has become part of a national movement in scholarship and performance to celebrate the works of William Shakespeare. The festival logo is popular with St. Louis students who attend performances and drama classes in Forest Park. (Courtesy Shakespeare Festival St. Louis/J. David Levy Photography.)

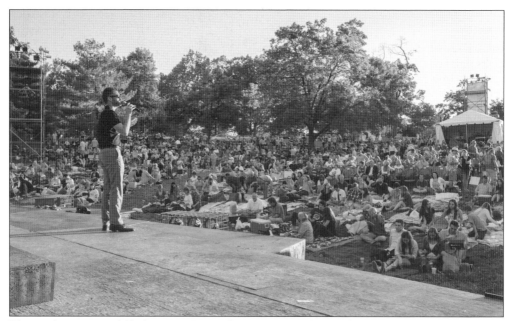

The performances of Shakespeare Festival St. Louis are free and open to the public. There is no need to worry about tickets or admission. Audiences often bring a picnic dinner or a bottle of wine with a cheese basket and spread out on a blanket on the grass or settle into their lawn chairs. (Courtesy Shakespeare Festival St. Louis/J. David Levy Photography.)

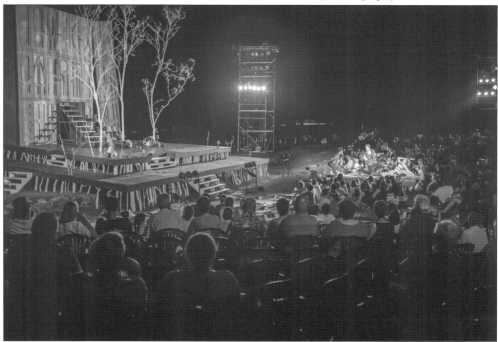

Shakespeare Festival St. Louis will soon mark 20 seasons of entertaining audiences in Forest Park. The festival boasts first-rate casts, stage settings, lighting, and sound. Musicians, dancers, singers, and jugglers often come down from the stage and mingle with audiences and perform throughout the crowd. (Courtesy Shakespeare Festival St. Louis/J. David Levy Photography.)

The Great Forest Park Balloon Race fills the St. Louis skies with balloons every year as summer melts into fall. Balloons first ascended from Forest Park at the Aeronautics Concourse of the 1904 World's Fair. There have been sporadic balloon launches over the years, but the annual organized balloon races of today date back to the 1970s. (Courtesy Forest Park Forever/ Stephen Schenkenberg.)

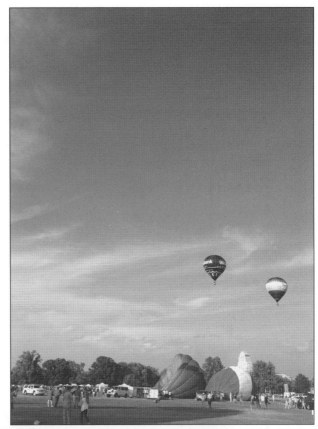

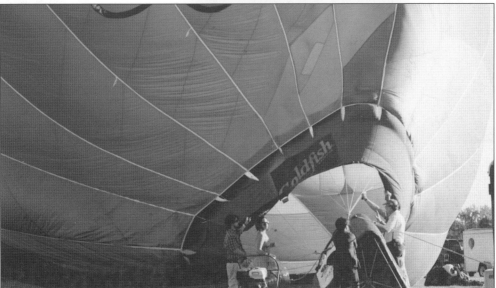

Balloon pilots and crews for the Great Forest Park Balloon Race are by invitation only for the event because organizers want experienced and proven talent. Most balloon races in America actually take place in rural areas. Taking to the skies in an urban setting like St. Louis can require special skills. (Courtesy Forest Park Forever/Once Films.)

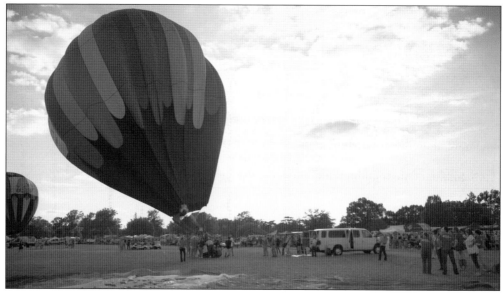

On the eve of Great Forest Park Balloon Race, balloon fans attend a night event called a "Balloon Glow." Crews get up early the next day to prepare for flight before Forest Park fills with as many as 100,000 people. They watch the balloons lift off the ground in a competition in which prevailing winds often take the pilots over the Mississippi River and into Illinois. (Courtesy Forest Park Forever/Once Films.)

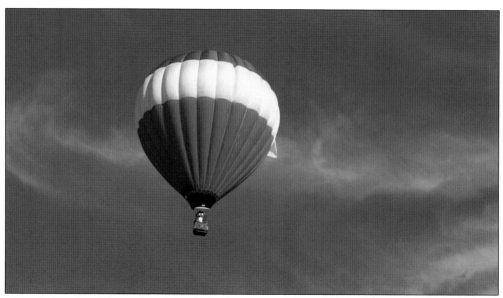

Clear September skies are ideal for the balloon race in Forest Park. Balloonists depend on the latest meteorological information before launching. Once the balloons are in the air, organizers maintain contact with Federal Aviation Administration officials in case the balloons drift too close to airports, such as St. Louis Lambert International Airport. (Courtesy Forest Park Forever/Once Films.)

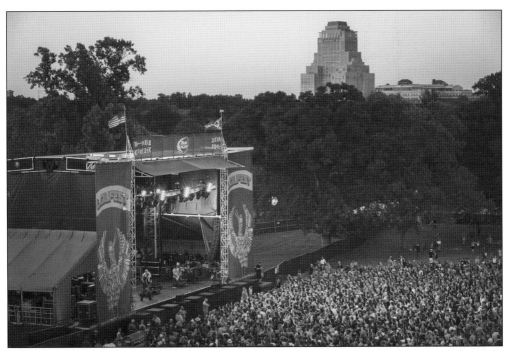

LouFest in Forest Park attracts larger crowds every year to enjoy such music genres as indie, rock, R&B, Americana, blues, country, and more. One-third of LouFest attendees live 100 miles or more outside of St. Louis. (Courtesy LouFest/Charles Reagan Hackleman.)

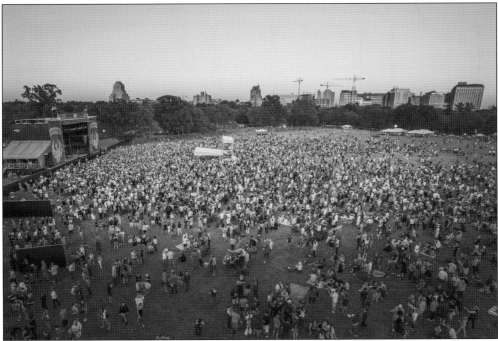

LouFest is a laid-back, multiday, musical extravaganza that works closely with Forest Park Forever, Gateway Greening, and Metro to create a sustainable event with a virtually carbon-free footprint in the park. (Courtesy LouFest/Charles Reagan Hackleman.)

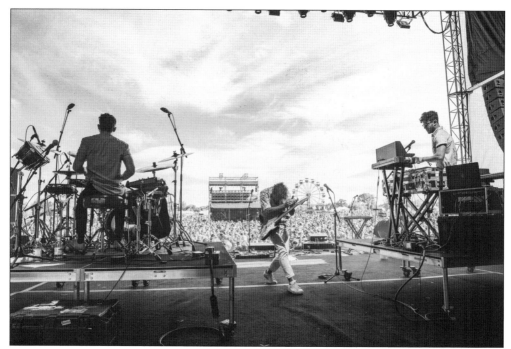

In just one decade, LouFest has grown to be one of the largest summer events in the St. Louis region. Attendance is now approaching 250,000. Past musical acts have included Chris Stapleton, LCD Soundsystem, Outkast, the Avett Brothers, Billy Idol, Wilco, Arctic Monkeys, and Ludacris. Forest Park as a music venue has proven to be a natural. (Courtesy LouFest/Charles Reagan Hackleman.)

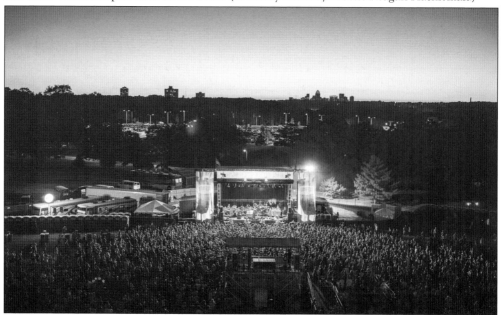

LouFest can feature as many as four outdoor stages with alternating performances. The festival grounds in Forest Park include a children's stage and village. A vendor area is designed to be environmentally-friendly, and the food court in the park offers fare from some of the unique neighborhood restaurants of St. Louis. (Courtesy LouFest/Charles Reagan Hackleman.)

The Jewel Box, dedicated in 1936 in Forest Park, has become the perfect location for destination weddings in St. Louis. Flowers grace every corner of the Jewel Box. Floral arrangements surrounding the Jewel Box are courtesy of the Flora Conservancy of Forest Park and the City of St. Louis. (Courtesy Holly Shanks.)

A saintly sentry at the Jewel Box in Forest Park is *St. Francis of Assisi.* He oversees the reflective pools for every wedding event at the Jewel Box. At the height of the June wedding season, the pools are filling with water lilies and alive with butterflies and other pollinators as well as dragonflies. (Courtesy Holly Shanks.)

Kite-flying has always been a favorite pastime in Forest Park when the weather conditions are right. Adding rock groups such as Kiss (pictured) or the Charlie Daniels Band to kite-flying happenings is one sure way guarantee a crowd. Kite-flying in Forest Park in the 1970s brought out thousands of baby boomers who poured into the park as music and hundreds of kites filled the air. (Courtesy Bill Parsons/KSHE Radio.)

Cool spring days punctuated by brisk breezes give St. Louis residents a good reason "to go fly a kite" in Forest Park. KSHE 95, an FM radio station that bills itself as "real rock radio," sponsored kite-flying contests in the 1970s. Some kites at the park were conventional, while other kite contraptions were massive and actually lifted their creators off the ground. (Photograph by Bill Greenblatt, courtesy KSHE Radio.)

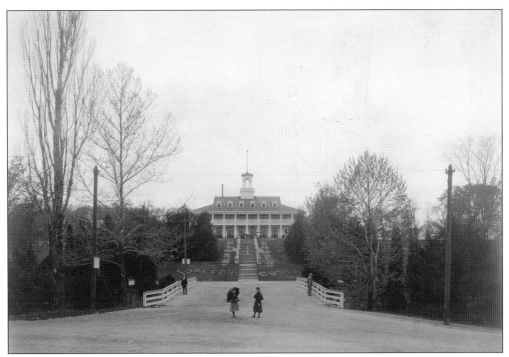

Forest Park in St. Louis serves as a dining destination and has a long history of pleasing palates. Proprietor C.W. Herbert operated one of the first restaurants, known as the Cottage, in 1891. It was advertised as having "prices not above those of first-class restaurants." Today, fine food can be found in all of the park's museums. (Courtesy Missouri History Museum, St. Louis.)

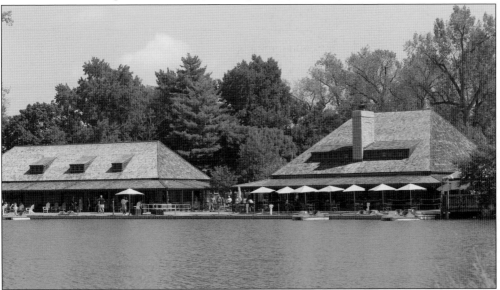

Boating fans can find a waterworthy vessel and a bite to eat at the Boathouse in Forest Park. The Boathouse hugs the shore of Post-Dispatch Lake, which got its name when the St. Louis newspaper launched a campaign to expand the lake in the early 1890s. By 1894, the lake had a concession operated for boaters. Today's Boathouse has a restaurant, bar, and plenty of outdoor dining. (Courtesy Holly Shanks.)

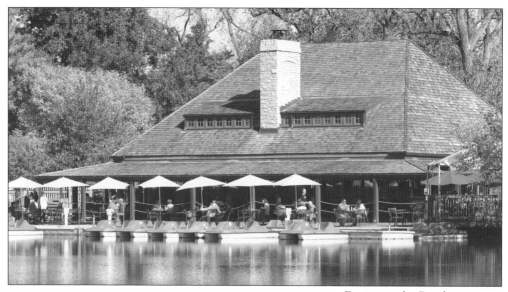

Dining at the Boathouse has become a year-round experience, thanks to a number of recent renovations. In balmy weather, boaters and landlubbers can enjoy drinks, live music, and the pleasures of lakeside feasting. In wintry weather, they can enjoy dinner or a hot chocolate near a large stone fireplace. (Courtesy Holly Shanks.)

Forest Park's Missouri History Museum is home to Bixby's, a fine restaurant with a famous St. Louis name. The restaurant is named for cultural philanthropist William K. Bixby, who served as president of the Missouri Historical Society from 1925 to 1930. His contributions to the cultural life of St. Louis and Forest Park came after a successful career in the railroad industry. (Courtesy Missouri History Museum, St. Louis.)

Spectacular views of Forest Park are available from the windows of Bixby's restaurant at the Missouri History Museum as well as from the floor-to-ceiling windows overlooking Art Hill at the Saint Louis Art Museum's Panorama Restaurant. The views of Forest Park from these dining facilities are as pleasing on snowy days in midwinter as they are on spring days when park trees are lush and green. (Courtesy Bixby's.)

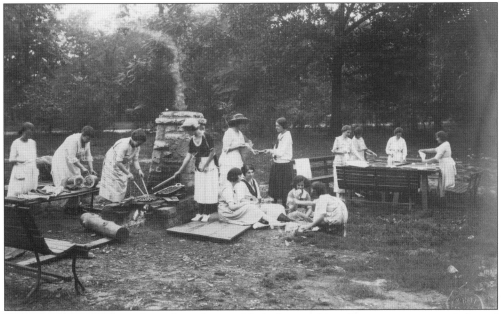

Dining in Forest Park can be as formal as a tablecloth spread in a fine restaurant or as informal as an outdoor picnic in one of the park's many nature nooks. Some of the first family picnics in Forest Park were in the 1890s when Fourth of July celebrations included bicycling, baseball, and lunching on the park lawn. (Courtesy Missouri History Museum, St. Louis.)

Forest Park on a summer's day can be "pretty as a picture." Art students from colleges and universities across the St. Louis region journey to Forest Park with their palettes, brushes, and easels. (Courtesy Forest Park Forever/Stephen Schenkenberg.)

*Nine*

# Honoring the Nation, the Planet
## Earth Day to Independence Day

America's birthday has been celebrated in Forest Park since its inception, but never as it was celebrated in the second decade of the 21st century. That is when Fair Saint Louis came to Forest Park after the St. Louis Arch grounds closed for renovation. Beginning in 2014, the park that hosted the 1904 World's Fair once again welcomed fairgoers, some of them descendants of the original 1904 revelers. They packed the sweeping lawns of Art Hill and beyond. During the day, the Family Festival Zone along Lagoon Drive and the Great Basin filled with parents and children. Youngsters were painted, mesmerized by magic, and wowed by Purina Dog Team tricks. On fair evenings over the years, crowds enjoyed the music of George Clinton, Eddie Money, Sammy Hagar, Bonnie Raitt, Blondie, Melissa Etheridge, and more. Music was followed by one of the greatest fireworks displays in America, eliciting oohs and aahs from more than a quarter million people.

"The performers love our July 4 week events because of the natural acoustics for their music," said general chairman of Fair St. Louis Steve Pozaric. "We have a natural bowl amphitheater from the top to the bottom basin area of Art Hill. It was actually designed that way going back to the 1904 World's Fair. At the end of the fireworks, we have asked audiences to help tidy up the grounds and it's amazing to see what happens. St. Louis has pride that Forest Park is always named one of the top ten urban parks in America and, of course, the park was rated number one in 2016 by *USA Today*. Residents cherish this park."

Forest Park has been a perfect setting to honor the nation's independence as well as to celebrate the future well-being of the planet. St. Louis marked its very first Earth Day in April 1970 in concert with America. As the Earth Day Festival grew in St. Louis, it found suitable locations in Forest Park—from Cricket Fields, to the Steinberg Rink, to the Missouri History Museum, to the Boathouse, and eventually, at the grounds surrounding the Muny. In 1990, more than 115,000 people attended the event at Cricket Fields, a solar-powered festival that included the first All-Species Parade. In 1992, the festival came to Steinberg Skating Rink where the Giant Puppet Pageant to Save the Earth was a highlight. Subsequent festivals enlisted the help of distinguished

officials such as Peter H. Raven, president of the Missouri Botanical Garden, and John Archibald, head of the Missouri History Museum. By the time the St. Louis Earth Day Festival found a home on the municipal theater grounds in Forest Park, the Muny site became known for one of the top five Earth Day celebrations in America. By 2016, the event attracted more than 250 organizations, vendors, and performers, including the Wild Bird Sanctuary, Circus Flora, and the American Tribal Style Belly Dance ensemble.

"Forest Park is a wonderful location for a communitywide celebration, but it's also an environment that remains wonderful through very diligent human care and planning," said Jean Ponzi, who has been involved with Earth Days since they began in 1970. "Having a mix of paved and planted areas helps accommodate many activities with minimal impact on the park. Green consciousness has been raised in the park with demonstrations and instruction on recycling, composting, water conservation, green energy, public transit, local organic foods, and more. Everyone agrees the public celebration of Earth Day finds a natural venue in our community's beloved Forest Park."

Forest Park has been called the heart of the city of St. Louis. Art Hill may well be the place where the city's heart beats. When the Fourth of July celebration known as Fair Saint Louis came to Art Hill, the evening drew up to a quarter million people who listened to the sounds of country, hard rock, reggae, and more. The statues atop the Beaux-Arts facade of the Saint Louis Art Museum and *King Louis IX of France*, atop his horse, always have the backs of Fair Saint Louis audiences. (Courtesy Fair Saint Louis.)

Forest Park's Grand Basin is the perfect centerpiece for a celebration of the nation's birthday, and it treats audiences to a glimpse of what the area looked like more than a century ago at the St. Louis World's Fair. Hours before the fireworks display, the basin waters shimmer with celebration lights as dusk ebbs into evening. The lake fountains have provided literally millions of droplets to reflect what is going on in a night sky filled with fireworks. (Courtesy Fair Saint Louis.)

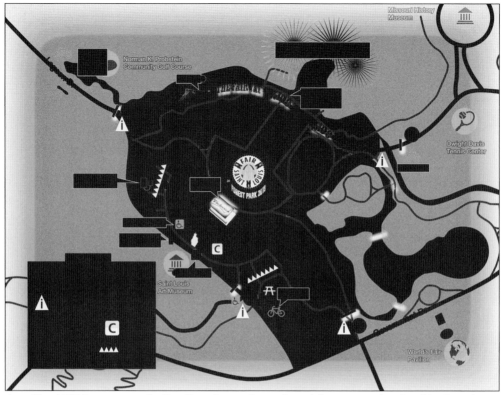

An official 2016 event map for Fair Saint Louis shows the celebration site bordered by four classic anchors: on the north is the Norman Probstein Community Golf Course and Clubhouse as well as the Dwight Davis Tennis Center to the northeast; directly south, there is the massive Saint Louis Art Museum, and the World's Fair Pavilion is to the southeast. In the spirit of both the past and the future, fair organizers encouraged biking to the event, with bike valets at three locations. (Courtesy Fair Saint Louis.)

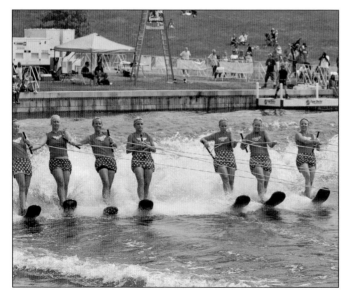

Skiing in the Grand Basin in 2014 for Fair Saint Louis posed special challenges for the water teams. In this small venue with concrete walls, the waves became a bit rougher than the skiers normally encounter. The fountains presented additional obstacles for the water entertainers and the boat drivers to navigate around. Lake Saint Louis Water Ski Club members were thrilled to perform in front of a large fair crowd, yet were always mindful of safety concerns. (Courtesy Fair Saint Louis/Eric Turmail.)

Kids have had plenty to keep them entertained at Fair Saint Louis. The Family Festival Zone is to be enjoyed by both parents and their broods. And nothing says Fourth of July in a more unique fashion than a character on stilts waving Old Glory. It does not matter how high those stilts take a person; there is still an opportunity to give high fives to a tyke creating memories in the favorite park of St. Louis. (Courtesy Fair Saint Louis.)

Dogs have not always fared well in Forest Park. At the 1904 World's Fair, a number of tribal peoples from around the world were on display in living exhibits. In the Philippine Village, the Igorots were a big crowd-drawer for their custom of eating dog for ceremonial purposes. Dogs have found a much safer venue with Fair Saint Louis, especially when entertaining audiences at the Purina Pro Plan Performance Team Area. (Courtesy Fair Saint Louis.)

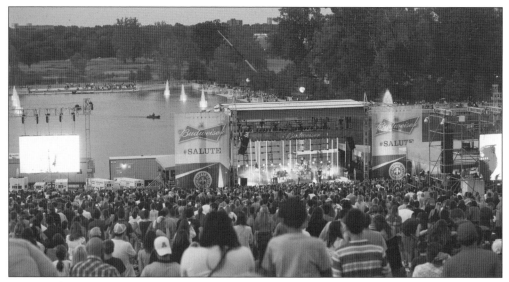

Forest Park transforms into Woodstock, albeit a little tamer music festival, during the evenings each year when hosting Fair Saint Louis. Some locations on the park hillside allow for the main stage to be bordered by the water fountains of the Great Basin. That scene can bring spectators to their feet, as can the music that echoes throughout the sprawling park. (Courtesy Fair Saint Louis/Roger Popwell.)

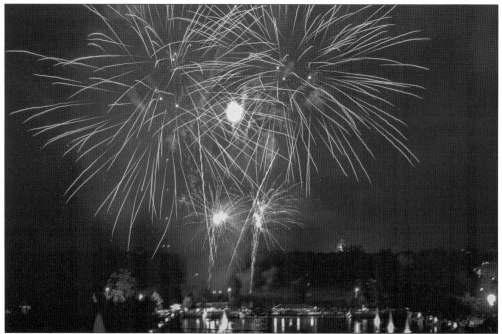

Great weather, fantastic music, cold drinks, foot-long corn dogs, and fabulous fireworks combine to make Fair Saint Louis an unforgettable Forest Park extravaganza—perhaps as unforgettable as that great 1904 World's Fair invention of the ice-cream cone. For youngsters, the great fireworks display over the Grand Basin at the park provide a dual treat: watching the rocket's red glare in both water and sky. Annual predictions that the noise and sparks in the night sky would spook the animals in the park's Saint Louis Zoo have never panned out. (Courtesy Fair Saint Louis/Roger Popwell.)

Environmentalists across America began celebrating Earth Day in April 1970 with massive coast-to-coast rallies. In 1989, St. Louis teacher and rainforest advocate Matt Diller turned the annual rally against pollution and denigration of the planet into the first St. Louis Earth Day Festival. The success and popularity of the first festival led to a much larger event in Forest Park in 1990 at Crickets Field. The festival was advertised with posters for Earth Day 90, and it included the first All Species Parade and the first use of solar power to energize Earth Day exhibits. "Make a Change" was the theme promoted by Kate Fish and Jean Ponzi, two key organizers of the 1990 event. (Courtesy St. Louis Earth Day.)

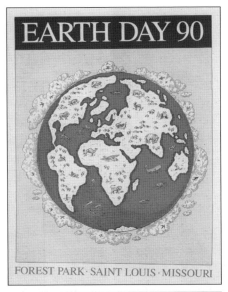

Although there is only one Earth Day every year in Forest Park in St. Louis, there is also an Earth Day Eve when festival organizers take time out from setting up vendor tents to smell the roses. Besides smelling flowers, they bike and hike, take a snooze under the spring canopy of trees, and dangle their feet in one of the many ponds close to the festival location near the Muny. Bucolic scenes, such as those visible on Earth Day Eve, give no hint of the commotion commencing when tens of thousands of participants converge in the park on the following day. (Courtesy St. Louis Earth Day.)

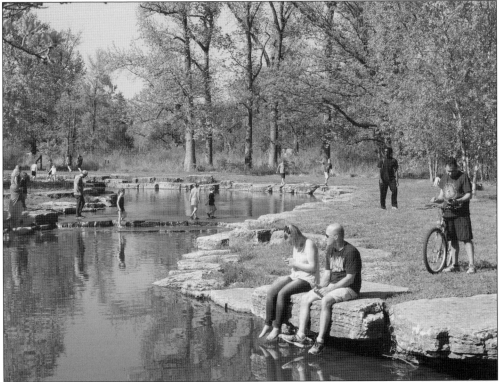

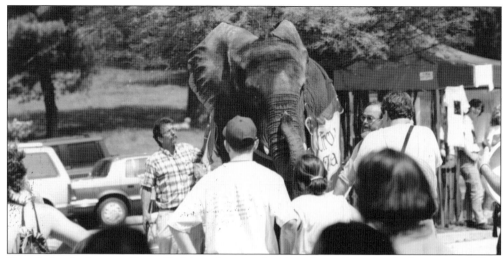

Not all the elephants at Forest Park have been in the Saint Louis Zoo. An elephant named Flora from Circus Flora attended St. Louis Earth Day during celebrations at the park throughout the early 1990s. Accompanying Flora is Ivor David Balding, cofounder and longtime ringmaster of Circus Flora in St. Louis. With each new Earth Day edition in Forest Park, more activities and programs have been dedicated to nature, animals, and preserving wildlife. (Courtesy St. Louis Earth Day.)

Some of the first Earth Day festivals in Forest Park were in the Steinberg Skating Rink area, where giant animal stick puppets from the All-Species Parade converged at the end of their march. They became part of a pageant and show with gorilla, zebra, bat, and giant worm puppets getting in on the action. After the pageant, festivalgoers wound around a giant Maypole—many of them transformed into sunflowers. Almost 115,000 people attended this 1990 Earth Day in Forest Park. (Courtesy St. Louis Earth Day.)

Standing like a sentinel overlooking the tents and activity of Earth Day is the Nathan Frank Memorial Bandstand built in 1925. The original bandstand was built in 1876 about the same time Forest Park opened. It was lost to fire but rebuilt and dedicated in 1925. It has been renovated several times, most recently in the 1990s by Forest Park Forever. The picturesque bandstand of Pagoda Lake provides some of the scenic charm of Earth Day in Forest Park. (Courtesy St. Louis Earth Day.)

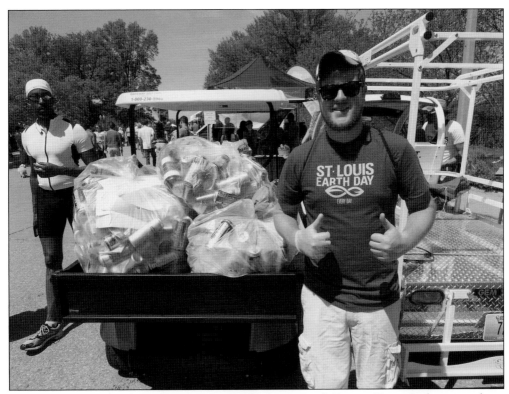

In an effort to reduce the carbon footprint of St. Louis Earth Day on Forest Park, visitors have been encouraged to walk, carpool, or ride a bike to the park and to use the special valet stations. Volunteers at the fair practice what they preach, finding ways to reuse or recycle the refuse materials discarded on the grounds. They have operated the Recycling Extravaganza, a free collection event at the park for hard-to-recycle items, from CFL (compact fluorescent light) bulbs to the odd appliance. (Courtesy St. Louis Earth Day.)

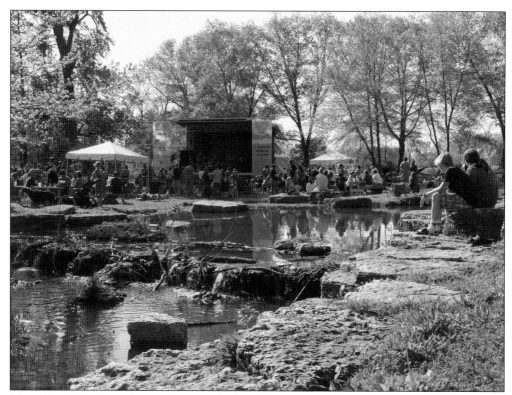

More than 30 fresh produce and organic food and beverage vendors and additional Green Dining Alliance–certified restaurant booths were on hand for the 2016 St. Louis Earth Day Festival. Earth Day organizers made sure there was plenty of music to fill ears in Forest Park. The Main Stage and Earth Day Cafe Stage featured original regional artists, including DJ Needles, Tortuga, Bruiser Queen, Arson for Candy, and more. Jake's Leg, which performed at the very first St. Louis Earth Day in 1989, was there to celebrate onstage again almost three decades later. (Courtesy St. Louis Earth Day.)

St. Louis mayor Francis Slay, a recycling advocate and 45th mayor of the city of St. Louis, has taken the stage at a number of Earth Day festivals to read a proclamation in support of local environmentalism. Slay was the first mayor of St. Louis to create an office of sustainability directly benefiting Forest Park. In 2016, St. Louis Earth Day Board of Directors president Traci Lichtenberg provided a proclamation for Slay recognizing his Executive Order 52, requiring recycling at all events taking place in the city, including at Forest Park. (Courtesy St. Louis Earth Day.)

# Ten

# FOREST PARK FOREVER
## KEEPING AND POLISHING A GEM

Dedicated in 1876, Forest Park will mark its sesquicentennial celebration in 2026. Just as there was plenty of "speechifying" about the park 150 years ago, the future holds many more deserved testimonials about the crown jewel of the St. Louis region. There will be boasts about the park's world-class cultural institutions: its zoo, history and art museums, innovative science center and planetarium, municipal opera, and the annual park events, from a great balloon race to a celebration of Earth Day—many happenings that have become traditions. There will be mention of the more than 13 million visitors to the park and the inevitable comparisons to New York's smaller Central Park.

Accolades and tributes notwithstanding, Forest Park has had its rough stretches over the years. The silver has tarnished. The glow of this gem has dimmed at times. In the 1980s, the park infrastructure was literally crumbling and some of its prime landmarks were deteriorating. The City of St. Louis and a nonprofit known as Forest Park Forever, established in 1986, teamed up to come to the rescue. They raised money to fund more than $100 million in reconstruction. And not too long after the turn of the 21st century, the two entities were able to show off amazing restorations of such treasured locations as Pagoda Circle, the Grand Basin, and the Boathouse.

"The City and Forest Park Forever are not resting; there are more projects in the works," said Greg Hayes, director of the St. Louis Department of Parks, Recreation, and Forestry. "Roads are being rebuilt at the north entrances of the park. We also have the restoration of the Central Fields, the location for the balloon races and the LouFest music events and other activities. We are connecting water features and we have restorations like the Liberal Arts Bridge between the Muny and the Boathouse in the works. We are proud of our restorations, but we are not really proud of our 'before' pictures. We are looking at plans to maintain and sustain what we have, so we won't be showing these 'before' pictures again in the future."

Forest Park Forever president and executive director Lesley Hoffarth can readily detail the ambitious master plan that rebuilt golf courses and athletic fields, refreshed lakes and waterways, and restored buildings and the Grand Basin—a place where charter buses now line up and where wedding parties seek perfect photographs with fountains and Art Hill as a backdrop. Forest Park Forever is about more than fundraising for repairs, rehabs, and restorations. It is also about public participation and public awareness about the park's natural and wildlife assets. To that end, Forest Park Forever wants to make sure that the park is an outdoor learning lab for all—particularly

113

for the young. For example, its Nature Works Program reaches out to high school students and introduces them to environmental jobs with outdoor education and work activities in the park's green space.

"We have a full-time outdoor education coordinator on our staff now," said Hoffarth. "We do programs with boys and girls clubs. We have a Voyage of Learning Teachers' Academy where teachers learn how to use the park for experiential learning and as an outdoor classroom for their students. We know that kids are not spending as much time outside as they used to. If we can get them outside, they are going to learn conservation and sustainability. And with a combination of classroom work and outdoor experiences, young people are going to learn and retain the lessons of stewardship of the land."

The Jewel Box was built in 1936 in Forest Park by the City of St. Louis. The name *Jewel Box* actually was used in Forest Park as early as 1926 to describe the beautiful floral displays in some of the park's greenhouses. (Courtesy Missouri History Museum, St. Louis.)

The Jewel Box facility underwent extensive renovations in 2002. According to a report from the National Register of Historic Places, great pains were taken in the design and orientation of the Jewel Box to provide light for plants in a nearly hail-proof building. (Courtesy Forest Park Forever/Jerry Naunheim Jr.)

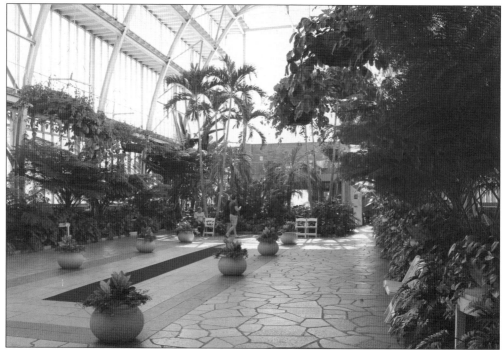

The Jewel Box was closed in 2002 for a $3.5-million renovation, and when it reopened in December of that year, visitors pronounced the inside transformation stunning. A central fountain was added and new amenities included a bride's room and catering facilities. Garden areas underwent a reconfiguration to enhance the floral displays for which the Jewel Box is famous. (Courtesy Holly Shanks.)

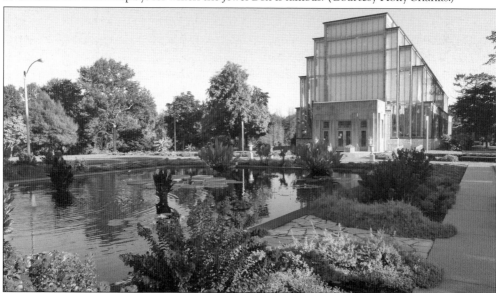

The exterior of the Jewel Box, a beautiful and unique display greenhouse, measures 144 feet long by 55 feet and has one-story stone appendages at the north and south ends. The vertical glass walls give little hint of what grows within. The walls are supported by steel arches that provide the interior with a large area of open display space uncluttered by support posts. (Courtesy Forest Park Forever/Calla Massman.)

Boating has been a popular activity in Forest Park since the park's opening in 1876, and with boating comes a house for boat rentals. The Boathouse is situated on a lake that has seen several expansions. In the 1890s, the *St. Louis Post-Dispatch* oversaw a campaign to raise funds and expand the lake. It then became Post-Dispatch Lake, which has been expanded with a more recent renovation of the Boathouse. The Boathouse became a renovation project after serious deterioration. (Courtesy Forest Park Forever/Jerry Naunheim Jr.)

Renovation of the Boathouse facility and the lake has been a $2.5 million endeavor. The project included construction of a new facility with an attractive restaurant and catering kitchen. The adjacent lake has been dredged and expanded. The new Boathouse is a design by St. Louis architect Laurent Torno. It has become a destination for diners with an appetite, rather than simply a site for boaters to have a snack. (Courtesy Forest Park Forever/Randy Allen.)

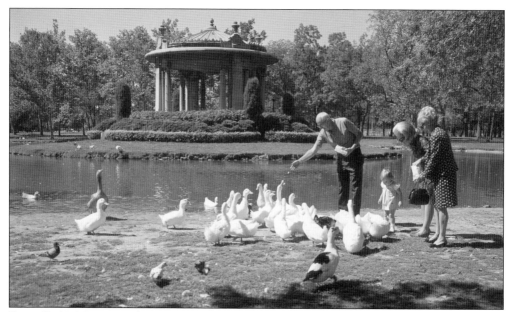

Forest Park's Music Pagoda was a magnet for music lovers in the late 1800s. They would arrive in their horse-drawn carriages to listen to afternoon concerts in a garden pavilion often compared to a structure out of *One Thousand and One Nights*. The pagoda was on a small island in the middle of Pagoda Lake. A storm destroyed the wooden building and the bandstand burned to the ground in 1912. A new pavilion was built of marble and concrete with a copper roof in the 1920s and came to be known as the Nathan Frank Bandstand. (Courtesy State Historical Society of Missouri, St. Louis.)

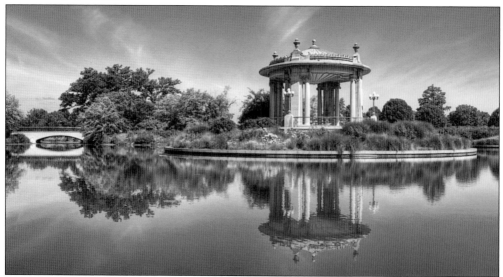

The Nathan Frank Bandstand and the Pagoda Circle area received much-needed attention in 1981, thanks to the Central West End Charitable Trust; it received even more attention in the 1990s, thanks to the restoration efforts of Forest Park Forever. The site is now a popular location for festivals and outdoor weddings. The City of St. Louis and the Flora Conservancy of Forest Park maintain the beautiful floral arrangements that enhance the circle area. (Courtesy Forest Park Forever/Randy Allen.)

The Grand Basin below Art Hill has been described as the centerpiece water feature of Forest Park, seen here around 1950. By the late 1980s, however, its water was stagnant, its walls were crumbling, and its landscaping was a jungle. (Courtesy State Historical Society of Missouri, Columbia.)

The Grand Basin today provides beautiful vistas of the many amenities of Forest Park for those who venture on its waters. The restoration of the basin area was funded by Emerson and Forest Park Forever. (Courtesy Holly Shanks.)

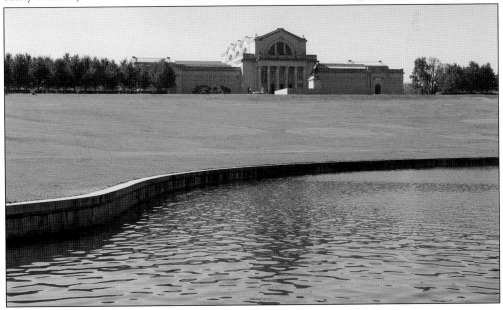

The Grand Basin area of Forest Park has been the pride of St. Louis residents since the 1904 World's Fair. The evidence of decline in the basin area became painfully obvious in the 1980s after years of deferred maintenance. Buildings, landscapes, and infrastructure were in critical disrepair. The bridge at the Grand Basin in Forest Park had become a crumbling mess and a disgrace for all those who remembered its past glory. (Courtesy Forest Park Forever/Jerry Naunheim Jr.)

The Grand Basin Bridge of today is transformed and has become a dramatic symbol of the restoration of Forest Park over two decades. The "Restoring the Glory" capital campaign from 1995 to 2003 provided the wherewithal for a critical round of infrastructure projects, including historical gems located in the Grand Basin area. The restored bridge is now an elegant centerpiece for artists and photographers, as well as a practical contrivance for transportation. (Courtesy Holly Shanks.)

High atop Government Hill in Forest Park, the World's Fair Pavilion has offered memorable views of the sprawling park grounds for more than a century. Despite the picturesque setting and the pleasing vistas, the pavilion itself was not so pleasing to the eyes by the late 1980s. The historic landmark fell into disrepair and needed a face-lift. (Courtesy *West End Word*/Nate Warren.)

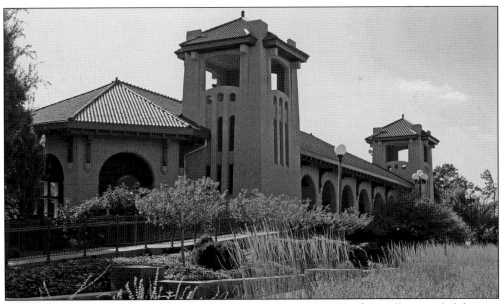

The World's Fair Pavilion saw a total renovation in 1998 with more than $1.1 million in rehabilitation funding. The exterior has been restored to its former glory, while the open-air interior of the pavilion has been modernized with lighting controlled by dimmer switches. The covered floor area can seat 500, with additional space at the east end of the pavilion. This new, improved pavilion gets rave reviews on Facebook but maintains the beautiful views of the park of a century ago. (Courtesy Holly Shanks.)

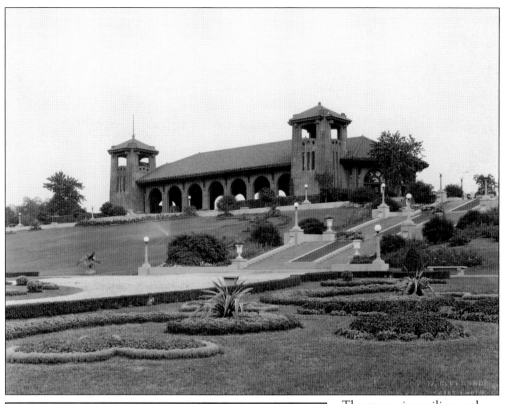

The open-air pavilion and shelter in Forest Park rates as one of the park's most popular and frequented locations since it was built in 1909 with proceeds from the 1904 World's Fair in St. Louis. It is seen here around 1935. (Courtesy Missouri History Museum, St. Louis.)

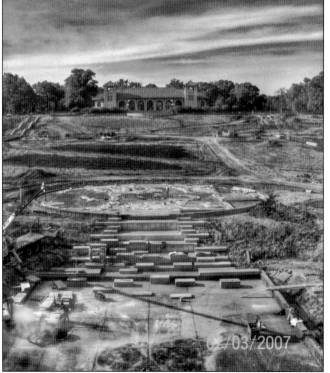

Restoration efforts at the World's Fair Pavilion included much-needed attention to its landscaping. The results of that massive undertaking are breathtaking when spring weather adds to the beautification. (Courtesy BSI Constructors, Inc.)

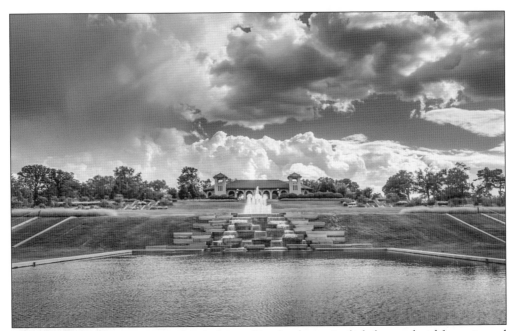

After the renovations were completed, the pavilion landscape included an updated fountain and cascading waterfall. The pavilion remains a popular attraction and photography spot for thousands of local St. Louisans and visitors. (Courtesy Forest Park Forever/Randy Allen.)

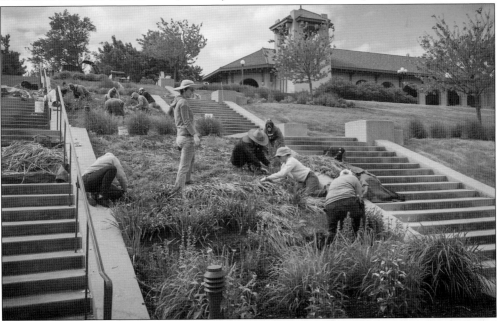

Forest Park Forever staff and volunteers plant and weed on the slope of Government Hill at the World's Fair Pavilion. More than 1,100 volunteers work in a variety of capacities, from planting bulbs, to trimming and weeding, to removing invasive plants such as honeysuckle. Volunteers have always been important to Forest Park in its more than 140 years, but never as important as today when urban centers such as St. Louis struggle with tight budgets. (Courtesy Forest Park Forever.)

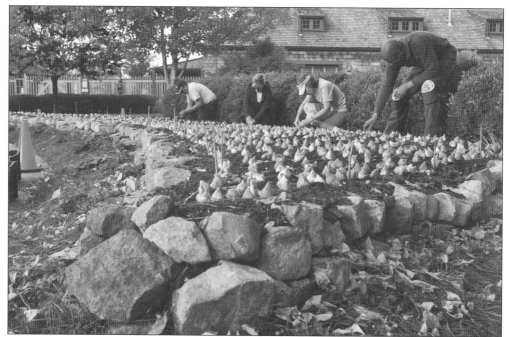

Forest Park Forever staff and volunteers plant bulbs for a seasonal display just outside the popular Boathouse. Some years, volunteers have planted as many as 50,590 bulbs and 4,560 trees across the park. St. Louis City partners have planted another 30,000 bulbs around the Jewel Box, in partnership with Flora Conservancy of Forest Park. (Courtesy Forest Park Forever/Patrick Greenwald.)

A Forest Park Forever horticulturalist prunes a tree near Government Hill. The horticultural team prunes 2,500 trees each year. Pruning is done in winter, when trees are dormant. Pruning is an ongoing project to give the trees the best structure and shape in their youth. This helps prevent branch failure due to wind, ice, and hail damage. The park suffered substantial tree losses in the tornado of 1927 and the ice storm of 2006. (Courtesy Forest Park Forever/Calla Massman.)

Forest Park has been an informal setting for learning about nature and the outdoors from the first day it officially opened in June 1876. Today, there is a need for more formal opportunities to learn about wildlife and open settings, especially when it comes to urban youth. Forest Park Forever sponsors outdoor classes for St. Louis youngsters to teach them about how much nature is available to them right in their own city park. (Courtesy Forest Park Forever.)

Forest Park Nature Reserve stewards provide educational plant walks to explore the many native wildflowers finding a home in the park. More than 500 native plant species can be found within the park's nature reserves. Park stewards are discovering more every year. A typical wildflower walk introduces students to the amazing plant diversity found in all the natural nooks and crannies of Forest Park. (Courtesy Forest Park Forever.)

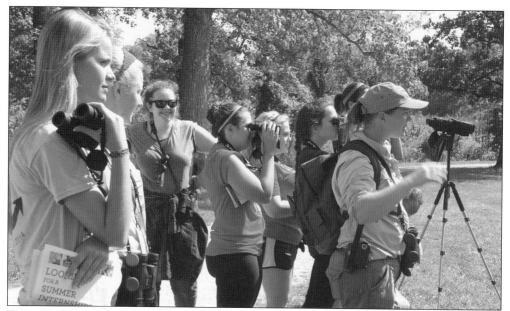

Forest Park Nature Reserve officers are available to lead groups of park visitors on birding expeditions. Cosponsored by Forest Park Forever and the St. Louis Audubon Society, these walks offer some of the best urban birding in the region. (Courtesy Forest Park Forever.)

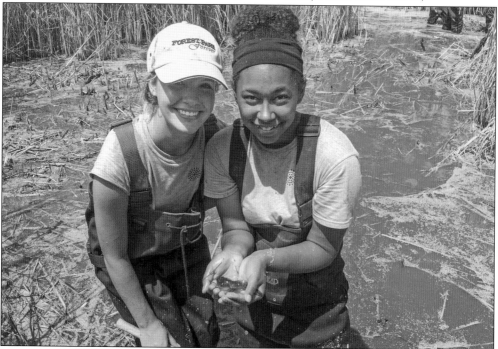

Members of Forest Park Forever's Nature Works Program discover a salamander that finds home in the park. The program increases the awareness of the vital role that native plant species and healthy wildlife habitats play in sustaining a high quality of life for all. Young people in the region and their participation in park programs are the key to the future of Forest Park. (Courtesy Forest Park Forever/Cassi Lundeen.)

# BIBLIOGRAPHY

Altman, Sally, and Richard Weiss. *The Jewel of St. Louis: Forest Park*. Marceline, MO: Walsworth Publishing, 2007.

Birk, Dorothy Daniels. *The World Came to St. Louis: A Visit to the 1904 World's Fair*. St. Louis: Chalice Press, 1992.

Bonner, Jeffrey P. *Sailing With Noah: Stories from the World of Zoos*. Columbia: University of Missouri Press, 2006.

City of St. Louis Department of Parks, Recreation, and Forestry Online Archives. Accessed July 29, 2016. https://www.stlouis-mo.gov/archive/history-forest-park/index.html.

Corrigan, Patricia. *Bringing Science to Life: A Guide from the Saint Louis Science Center*. St. Louis: Virginia Publishing Co., 2007.

Craske, Oliver, Sarah Peacock, and Andrew Shoolbred. *Forest Park, Saint Louis*. London: Scala Publishers, 2007.

Fox, Elana V. *Inside the World's Fair of 1904: Exploring the Louisiana Purchase Exposition*. Bloomington, IN: 1st Book Library, 2003.

Horgan, James. *City of Flight: The History of Aviation in St. Louis*. Gerald, MO: Patrice Press, 1984.

Jackson, Robert. *Meet Me in St. Louis: A Trip to the 1904 World's Fair*. New York: HarperCollins, 2004.

Kimbrough, Mary. *The Muny: St. Louis' Outdoor Theater*. St. Louis: Bethany Press, 1978.

Loughlin, Caroline, and Catherine Anderson. *Forest Park*. Columbia: University of Missouri Press, 1986.

McCue, George. *The Building Art in St. Louis: Two Centuries; a Guide to the Architecture of the City and Its Environs*. St. Louis: St. Louis Chapter, American Institute of Architects, 1967.

———. *Sculpture City: St. Louis*. Photographs by David Finn and Amy Binder. New York: Hudson Hills Press, 1989.

Perkins, Marlin. *My Wild Kingdom: An Autobiography*. New York: E.P. Dutton, 1982.

Pisano, Dominick A., and F. Robert van der Linden. *Charles Lindbergh and the Spirit of St. Louis*. New York: Harry N. Abrams, 2002.

# DISCOVER THOUSANDS OF LOCAL HISTORY BOOKS FEATURING MILLIONS OF VINTAGE IMAGES

Arcadia Publishing, the leading local history publisher in the United States, is committed to making history accessible and meaningful through publishing books that celebrate and preserve the heritage of America's people and places.

Find more books like this at
## www.arcadiapublishing.com

Search for your hometown history, your old stomping grounds, and even your favorite sports team.